SNAPSHOT

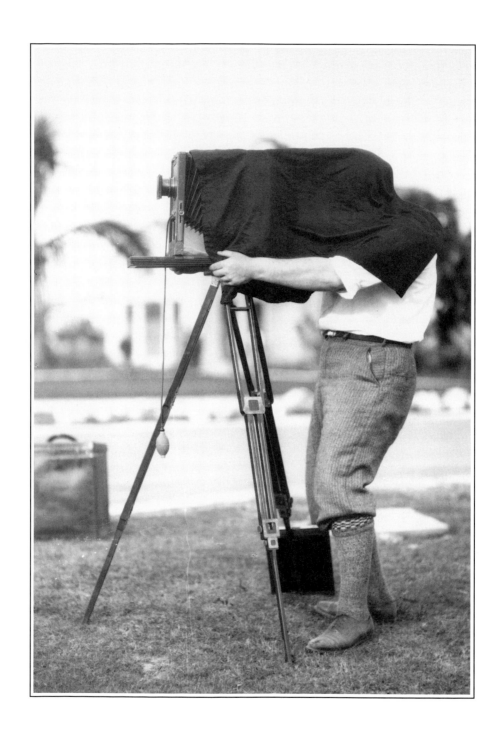

SNAPSHOT

America
Discovers the Camera

Kenneth P. Czech

Lerner Publications Company • Minneapolis

To Mary, who shares a love of history and books

Thanks to Yale Greenfield for his assistance with this book

Library of Congress Cataloging-in-Publication Data

Czech, Kenneth.
 Snapshot : America discovers the camera / Kenneth Czech.
 p. cm.
 Includes bibliographical references and index.
 ISBN 0-8225-1736-1 (alk. paper)
 1. Photography—United States—History—19th century. 2. Photography—United States—History—20th century. 3. Photography—Social aspects—United States—History—19th century. 4. Photography—Social aspects—United States—History—20th century. I. Title.
TR23.C94 1996
770'.973—dc20 95-51136
 CIP

Manufactured in the United States of America
1 2 3 4 5 6 - JR - 01 00 99 98 97 96

Contents

PORTRAITS AND PLATES

No moving, please, for sixty seconds.

—American photographer,
mid-19th century

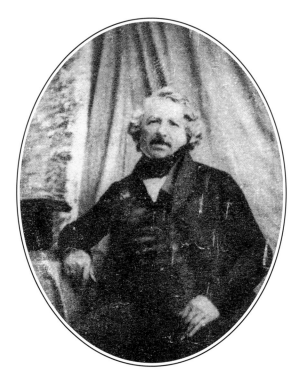

The year was 1840. Sunlight blazed into an upper-story room of a New York City building. The heat was nearly unbearable, but the proprietor calmly assured his clients, a husband and wife, that they had to sit still for only a few more seconds. Clamps prevented them from turning their heads so much as an inch. The proprietor glanced at his watch, waited an instant longer, then nodded.

"You can relax now," he said.

The clients sighed with relief. They had been sitting under bright light—in heavy woolen clothing, backs ramrod straight and necks clamped into place—for many minutes. But the uncomfortable session would all be worthwhile. A combination of sunlight, a glass lens, and

chemicals had captured the couple's image on a silver plate. They would soon be looking at a portrait of themselves. Not a painting or a sketch—but a photograph.

PICTURES ON SILVER PLATES

Paris, France, was abuzz with excitement during the summer of 1839. Rumors rippled from street corner to marketplace concerning Louis Daguerre's latest invention. Could it really be true? Had Daguerre actually captured exact images of people and buildings on a sheet of copper? Parisians who had seen the silver-treated copper plates found the images "positively true to nature." Some people claimed the pictures were demonic, while others believed that the images would drive portrait painters and other artists out of business. A few people recognized Daguerre's work for what it was—an invention that would revolutionize the world.

Head clamps helped customers hold still while their pictures were taken.
Opposite: Louis Daguerre discovered a way to fix images on metal plates.
The process was named daguerreotypy.

Louis Daguerre's discovery was not completely new. For hundreds of years, artists had been using a device known as a camera obscura—a large, dark box pierced on one side by a small pinhole—to project images onto paper. Illustrators then traced the images. Artists, draftsmen, and scientists used variations on the camera obscura to make accurate drawings for their work. As early as 1799, inventors tried to find chemicals that would fix an image on a metal plate within the box. Then illustration wouldn't be necessary.

In 1826, French physicist Joseph-Nicéphore Niepce inserted a chemically treated pewter plate into a primitive camera. Like the camera obscura, Niepce's camera was a dark box. Instead of a pinhole, the camera had a simple glass lens for focusing sunlight. Niepce directed his camera from his window toward the roof of a nearby barn. Sunlight flooded the camera for eight hours. The procedure was a success: the image of the roof was imprinted on the pewter plate. Though the picture was faint

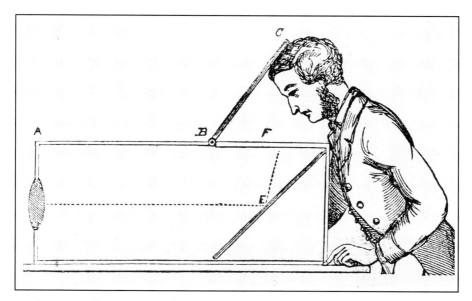

Light enters this camera obscura through a lens. The image forms in a mirror. Some camera obscuras were so large that a person could sit inside them and sketch images.

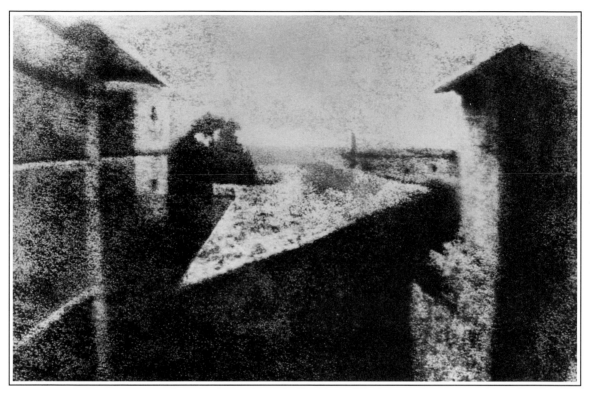

This view through Joseph Niepce's window is considered the world's first photograph.

and lacked detail, it was the world's first true photograph (from the Greek words for light, *phot,* and writing, *graphos*).

Four years later, Niepce went into partnership with painter Louis Daguerre, who spent the next ten years experimenting with different chemicals, trying to perfect the photographic process. Unfortunately, most of Daguerre's pictures faded rather quickly. Once, when Daguerre placed some faded metal plates in a storage cabinet, he accidentally exposed them to mercury vapors from a broken thermometer. When he retrieved the plates a few days later, he found that the faded images had become distinct. Mercury proved to be the proper chemical for developing photographs—that is, for making them visible.

The new photographic process, dubbed the daguerreotype, caused a sensation among Parisians. When the process was described to the French Academy of Arts and Sciences, thousands of citizens crowded the banks of the Seine River to catch snatches of information. "An hour later," wrote one eyewitness, "all the opticians' shops were besieged, but could not rake together enough instruments to satisfy the onrushing army of would-be daguerreotypists; a few days later you could see in all the squares of Paris three-legged dark-boxes planted in front of churches and palaces." Aspiring photographers scoured stores for eyeglass lenses and artists' tripods—anything that could be used to piece together a camera.

News of Daguerre's discovery soon reached Great Britain. "[The photograph] is one of the most beautiful discoveries of the age," noted American inventor Samuel F. B. Morse, who was traveling in Europe at the time, ". . . no painting or engraving ever approached it." English newspapers quickly printed details of Daguerre's methods and, as in Paris, Londoners began to experiment.

On a warm September afternoon in 1839, the steamship *British Queen* dropped anchor in New York. Nestled in the ship's hold were bundles of the London *Globe,* carrying a description of Louis Daguerre's photographic process. Hundreds of readers swarmed around the docks, buying copies of the newspaper as fast as they could be unloaded. Within a week, publishers in Washington, Baltimore, and Philadelphia had all reprinted the daguerreotype story. Like the Europeans, amateur American photographers copied the Daguerre method, scrounging through optical shops for lenses.

TAKING LIKENESSES

Before the development of the daguerreotype, portraits were hand-painted on canvas—a time-consuming process that only the wealthy could afford. Photography, however, produced an exact likeness of a person at a fraction of the cost. Soon, Americans from all walks of life were flocking to makeshift studios for a portrait. "It was no uncommon thing to find watch repairers, dentists, and other styles of business folk to carry

on daguerreotypy 'on the side,'" recalled one early photographer. "I have known blacksmiths and cobblers to double up with it, so it was possible to have a horse shod, your boots tapped, a tooth pulled, or a likeness taken by the same man."

But having a portrait taken in the 1840s and 1850s was not always a pleasant experience. Properly exposing an image with an early camera required bright sunlight. Photographs had to be taken outside or in special studios with large skylights. Those who posed for the camera in 1839 and 1840 had to sit for as long as 30 minutes in the hot sun. By 1841, thanks to improved lenses and more effective chemicals, exposure times had been reduced to less than a minute. Still, the slightest movement during a sitting usually created a blurred image. To keep clients from nodding or turning, photographers devised headrests and neck clamps. Perhaps that's why early portraits show stern and serious faces—the process was uncomfortable, and no one could hold a smile for very long.

Photographers also had to carefully time the plate's exposure to sunlight. Without enough light, the plate would not hold an image. Too much light overexposed the plate—the image looked too bright. So photographers kept a close eye on the sky, watching for sunshine, storms, and cloudy weather. A poem of the era summed up the procedure:

> Whene'er the wind is in the East,
> Use twice the seconds at the least.
> And if the East incline to North,
> Take not the wretched sitter forth.
> Come cloud electric, or of hail,
> Then every picture's sure to fail.
> But with light zephyrs from the West,
> In scarce five seconds 't is imprest:
> And if the West incline to South,
> In three you have eyes, nose and mouth.

By 1855 more than 90 portrait studios competed for business in New York City alone. John Plumbe Jr. owned 14 studios in various cities. Mathew Brady, who studied daguerreotypy under Samuel Morse, ran

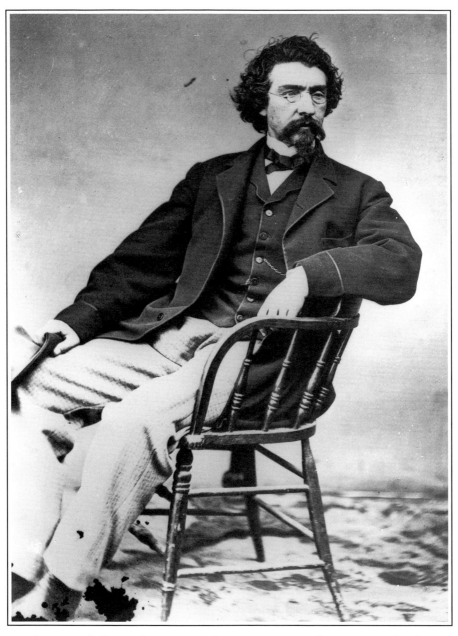

Mathew Brady began his career taking portraits and went on to lead a famous team of Civil War photographers.

large studios in Washington, D.C., and New York. His gallery on Broadway was decorated with "satin and gold paper on the walls, embroidered draperies over the windows, an enameled chandelier hanging from the ceiling and the floors carpeted with superior velvet tapestry." Brady specialized in large photographs—17 by 20 inches—and counted presidents, explorers, and politicians among his customers.

Small towns also boasted photographers. Sam F. Simpson opened a studio aboard a flatboat on the upper Mississippi River. He advertised:

> Our flat-boat Gallery . . . is fitted out with every convenience for taking likenesses. In front of all is the reception room, back of that, the sitting room, and still further back the chemical room. In our sitting room we have a large side and sky light that enables us to operate in from five to ten seconds in fair weather. If business is good we can remain as long as we please; if dull, we can leave. When we are not employed, we can fish or hunt, as best suits our fancy, as the rivers are thronged with ducks and wild geese.

In the national census of 1850, 938 men listed their profession as daguerreotypist. America's first photography magazine, the *Daguerrian Journal,* was published in New York in that year. By 1853, the *New York Tribune* reported, more than three million daguerreotypes were being produced annually. The invention even influenced literature. In Nathaniel Hawthorne's *The House of Seven Gables* (1851), a photographer named Holgrave takes daguerreotypes of the evil Judge Pyncheon. The portraits, when developed, reveal the judge's dark side.

Competition was fierce among photographers, who lured subjects to the studio with a variety of props. They hung painted backdrops and curtains behind clients to give photographs an outdoors or exotic look. A curtain might be painted with an elaborate winding staircase or a mountain scene complete with waterfall. Some photographers posed subjects on a swing. Of course, the swing could not move or the picture would be blurred. So the swing stayed permanently at rest—its "ropes" in reality were stiff cords not even attached to the ceiling.

Though children were favorite photography subjects, they had a tendency to squirm while sitting for a portrait. Many photographers shot children between 10 A.M. and 2 P.M., when sunlight was strongest and exposing a restless subject took less time. Photographers provided young subjects with jumping jacks and music boxes to hold their attention. A few even kept pets in the studio.

In the early 1850s, a 6½-by-8½-inch metal plate portrait cost about

Subjects had to sit perfectly still when posing.

$10. More common were smaller plates—2¾ by 3¼ inches—for a more affordable $2.50. As more and more people got into the daguerreotype business, prices fell. By 1853, some photographers were offering portraits for twenty-five cents apiece. Their studios were very plain, with no frills attached to the service. Customers were ushered into a portrait room, faced the camera for a quick photograph, then left by a side door.

An angry Mathew Brady, concerned that sinking prices might affect his business, wrote to the local newspapers: "New York abounds with announcements of 25 cent and 50 cent Daguerreotypes. But little science, experience, or taste is required to produce these, so called, cheap pictures." But Brady was powerless to stop his competitors. And the era of metal plate photography was coming to an end anyway. In the years that followed, photographs would become even cheaper and easier to take.

NEGATIVE TO POSITIVE

Metal-plate daguerreotypes could not be reprinted or reproduced. Photographers discovered that printing would require transparent plates. Metal, of course, was not transparent. In addition, metal plates captured a positive image. That is, the image on the plate looked exactly like the image in front of the camera—light areas were light and dark areas were dark. Printing required *negative* images, in which light areas appeared dark and dark areas appeared light. Negative images could then be printed as positive images on paper.

Photographers first experimented with paper negatives. Englishman William Henry Fox Talbot, considered by many to be the true father of photography, had captured negative images on pieces of fine writing paper as early as 1839. But since the paper was not transparent, it imparted its own texture on the final print. In 1851 English inventor Frederick Scott Archer discovered a process of capturing negative images on glass. Each glass plate could then be used to make an unlimited number of high-quality prints on paper.

Named the "wet-plate process," Archer's method involved coating a glass plate with a gluey chemical mixture called collodion. Collodion

greatly reduced exposure times—to just a few seconds. But the chemicals in collodion evaporated quickly. Once coated, a plate had to be inserted in the camera, exposed to sunlight, and developed in a lightproof "darkroom" immediately—before the liquid coating dried.

Printing, like developing, involved a series of chemical treatments in the darkroom. Photographic prints were made on specially coated paper; the most successful coating was made from albumen, the white of an egg. Instructions for preparing albumen coating sounded like something from a cookbook. Photographers were told to separate egg white from the yolk and to whisk it with whey, derived from curdled milk. The instructions continued: "This solution is then to be boiled and again filtered, after which five grains per cent of iodide of potassium is to be dissolved in it."

Hundreds of millions of eggs were broken to make albumen paper. One Chicago photography supply firm billed their eggs as "Hen Fruit" and promised: "They will not blister or soften in the Solutions." Yolks were sometimes sold to bakeries or leather tanners, but often were simply wasted.

While collodion and albumen made the photographic process simpler and more affordable, customers still had a common complaint: after a few years, photographs began to fade. A combination of handling, exposure to air, and the chemicals used in developing caused images to dull and even disappear. A poem in the British magazine *Punch* summed up the problem:

> Behold thy portrait—day by day,
> I've seen its features die;
> First the moustachios go away
> Then off the whiskers fly.
>
> Thy hair, thy whiskers, and thine eyes,
> Moustachios, manly brow,
> Have vanished as affection flies—
> Alas! where is it now?

Many photographers turned to artists to help them protect portraits. With crayons, watercolors, and oil paints, artists outlined images and filled in colors. They often covered up blemishes, strands of hair, and unsightly moles or scars on a subject. Some clients even asked artists to make them look thinner. The layer of paint often preserved the image, while the actual photograph beneath faded away.

STUDIOS ON WHEELS

Not all small towns had a photography studio. But if Americans couldn't come to the camera, the camera came to them. With the wet-plate process came a new sight on the American landscape: the traveling photographer's wagon.

Working on the road presented special problems for photographers. Glass plates had to be developed immediately after exposure to sunlight. So a traveling cameraman had to rush plates to a collapsible tentlike darkroom, set up on the back of his wagon and carted around with everything else he needed: cameras, lenses, tripods, chemicals, developing pans, distilled water, glass plates.

Throughout the 1850s, photographers prowled the countryside, and Americans rushed to have their portraits taken. But darker images were looming on the horizon. Debates over slavery and states' rights were about to fracture the country. By 1860 the camera was already capturing the faces of young soldiers in a series of haunting portraits. The Civil War was near, and the photographer and his wagonload of gear would be present to capture images of American fighting American.

WITNESS TO WAR

I felt that I had to go. A spirit in my feet said "go," and I went.
—Mathew Brady on photographing the Civil War

"Ho! For the Sunny South!" declared a recruiting poster in Troy, New York. "Preserve the Union, Protect the Constitution."

When the opening shots of the Civil War were fired in April 1861, neither the Northern nor Southern states were ready for war. The federal government had about 16,000 regular soldiers, while the army of the newly formed Confederate States of America was a makeshift outfit. Both sides needed more men in uniform—immediately!

Presidents Abraham Lincoln of the Union and Jefferson Davis of the Confederacy issued proclamations calling for tens of thousands of volunteers. Countless cleverly worded and colorfully illustrated recruiting posters invited men to fight for their country and to win honor and glory.

Young men left jobs, homes, and loved ones to join the army and navy. Before leaving, many recruits took time to have their portraits taken.

"AN EXCELLENT MEANS OF ELECTIONEERING"

By 1861, new developments in photography were sweeping the nation. In 1850, Frederick and William Langenheim of Philadelphia had invented a camera with two lenses, about two and a half inches apart—roughly the distance between human eyes. The camera took twin photos of a subject, each image from a slightly different angle. Both photographs were printed side by side on a rectangular card.

Dubbed a stereograph by author Oliver Wendell Holmes, the card was viewed through a handheld device called a stereoscope. "By this method," noted a Chicago newspaper, "one picture is seen by one eye and the second by the other, yet the two blend in the vision and form a more perfect image than can be formed in other known methods. It seems to stand out from the plate and possess the fullness of reality."

Viewed through the stereoscope, the twin pictures seemed to present depth and distance. Stereographs became a type of entertainment in the 1850s. Family members gathered in the evening and passed around cards and the stereoscope. Stereographs were traded with neighbors and relatives. "I think there is no parlor in America where there is not a Stereoscope," observed Dr. Hermann Vogel, a German traveler in the United States. Stereographs had captured the American imagination.

So too had *carte de visites,* or visiting cards. In 1854, Adolphe-Eugène Disdéri of France developed a camera with multiple lenses and a plate holder that moved. This concept allowed photographers to make as many as 12 images of the same subject on a single wet-plate negative. The images were printed on card paper and the 12 portraits cut apart. The tiny portraits, some as small as a postage stamp, were mounted on small cards, similar to modern business cards.

Carte de visites had an immediate impact. Businessmen exchanged cards while completing transactions. Parents brought their children to studios yearly for carte de visites, used to record growth and to share

with friends and relatives. Soldiers posed for card photographs because they were relatively cheap—about three dollars per dozen.

Stereographs and carte de visites were produced in the millions in the mid-19th century. Another novelty was the tintype, a photograph developed on a blackened plate of sheet metal, then varnished. Tintypes were cheaper and more durable than card photographs. However, white portions of the photograph appeared gray and didn't contrast much with darker portions. Later, more pleasing chocolate-brown tintypes appeared.

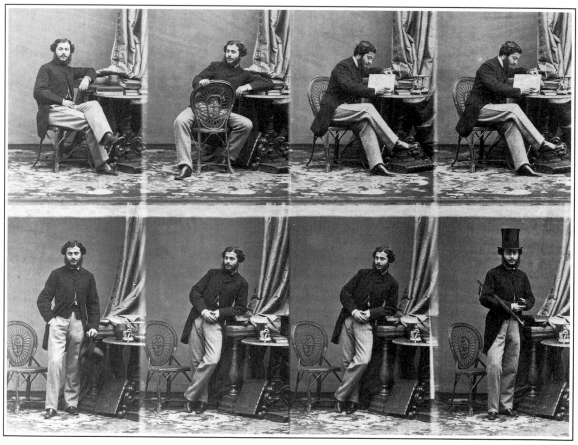

Carte de visites were made on a single plate and cut apart after printing.
The subject could strike a new pose with each exposure.

In the summer of 1860, photographer D. F. Maltby began producing tintypes bearing images of presidential candidates—campaign buttons. With bitter conflicts dividing the country, voters were choosing sides, proudly wearing buttons to show support for their favorite candidates: Stephen A. Douglas (Democratic Party), John Breckinridge (States' Rights Party), John Bell (Constitutional Union Party), or Abraham Lincoln (Republican Party).

Few voters, particularly in the eastern United States, had ever seen Abraham Lincoln. Those who didn't like him often described him as a freak: "Mr. Lincoln stands six-feet-twelve in his socks, which he changes every ten days," wrote one opponent. "His anatomy is composed mostly of bones, and when walking he resembles the off-spring of a happy marriage between a derrick and a windmill." What was the public to think?

Abraham Lincoln was indeed a bit awkward looking at six feet, four inches, and his face was heavily lined. When he appeared in Washington to give a speech in February 1860, he was not fashionably dressed, nor did he look much like presidential material. His Republican friends took him to Mathew Brady's portrait studio for photographs.

"I had great trouble in making a natural picture," Brady said later. "When I got him before the camera I asked him if I might not arrange his collar, and with that he began to pull it up. 'Ah,' said Lincoln, 'I see you want to shorten my neck.' 'That's just it,' I answered, and we both laughed." According to Vicki Goldberg in *The Power of Photography,* "Brady's full-length portrait made Lincoln seem much more reasonably put together than he was and, with some retouching, it softened the harsh lines of his face, making him look dignified, wise, statesmanlike, and compassionate."

Hundreds of thousands of copies of Abraham Lincoln's portrait flooded cities and towns. Many appeared as carte de visites, available not only in bookstores but also in livery stables, saloons, and general stores. Though the technology did not yet exist to print the photograph in newspapers and magazines, artists made woodcuts based on the picture. Almost overnight, Lincoln's image became well known to Americans. One

Lincoln supporter noted, "I am coming to believe that likenesses broad cast, are excellent means of electioneering."

THE SOUTH BREAKS AWAY

The election of Abraham Lincoln as president pushed the Southern states to secede, or withdraw, from the Union. When Confederate troops fired on Fort Sumter in South Carolina's Charleston harbor on April 12, 1861, the break between North and South was complete.

As armies marched to war, tintype photographers followed. During the summer of 1862, at a Yankee (Union) encampment near Fredericksburg, Virginia, a correspondent for the *New York Tribune* noted: "One of the institutions of our army is the traveling portrait gallery. A camp is hardly pitched before one of the omnipresent artists in collodion and amber-bead varnish drives up his two horse wagon, pitches his canvas-gallery, and unpacks his chemicals. . . . The amount of business they find is remarkable. Their tents are thronged from morning to night."

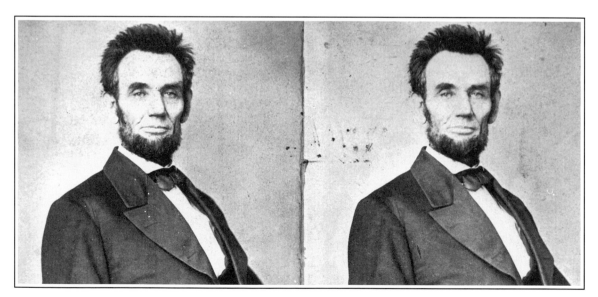

When viewed through a stereoscope, this stereograph of President Lincoln looked like a single image, seeming to have depth.

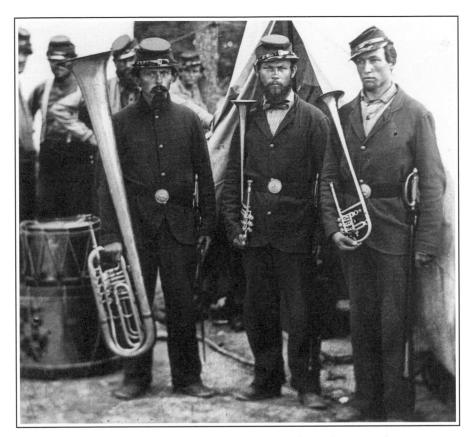

Band members with instruments, Fourth Michigan Infantry

It was natural for a soldier to want to send his likeness to loved ones. Tintypes and card photographs were mounted in elaborate cases and frames and shipped to anxious families and friends. "An immense transportation business has been done by the Post Office," noted one observer. "Not infrequently a number of bags go out from the Washington office entirely filled with sun pictures [tintypes], enclosed in light but bulky cases."

Tintypes came in a variety of sizes, ranging from miniatures measured in fractions of an inch to 6½-by-8½-inch plates. Miniatures were often mounted on rings or pendants, so wearers could keep the soldier's image

close at hand. Occasionally, families had tintypes hand-colored by an artist for a more lifelike look.

But it didn't matter if a soldier's portrait appeared as a daguerreotype, a carte de visite, or a tintype. All the photographs revealed young and sometimes middle-aged men clad in the uniforms of their armies. Photographers posed clients with a variety of military props ranging from bowie knives and swords to pistols and bayoneted rifles. Thirteen-year-old drummer boys proudly displayed their instruments. Officers appeared fearless and noble. For many men marching to the unknown horrors of war, these portraits would be their last.

Reporters were ready for war too. Typically, journalists and illustrators traveled with armies, recording scenes of camp life and battle. Drawings were usually made after a battle, so illustrators sketched from memory. More often than not, the artist was not an eyewitness and had to reconstruct a battle scene from descriptions provided by soldiers. Engravings

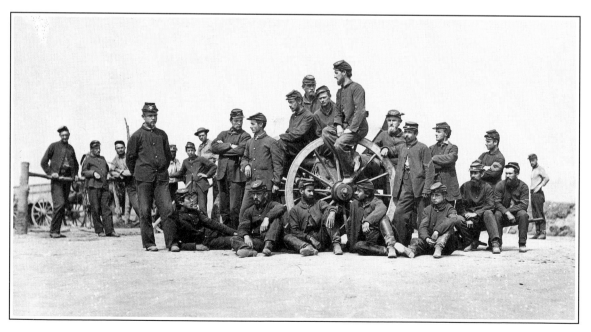

Union artillerymen, 1862

appearing in weekly newsmagazines were usually part factual and part fictional—drawn from the artist's imagination.

With the introduction of the camera, however, scenes could be recorded as they existed. Early photographers had followed General Winfield Scott and his army in the war against Mexico (1846–48) and had taken several dozen daguerreotypes. These photos mostly showed American troops in Mexican cities.

BRADY'S CORPS

Mathew Brady felt it was his patriotic duty to photograph the Civil War. He expected the war to be short and, joining with the Union army, thought he'd soon be taking pictures of victorious Union soldiers in the Confederate capital at Richmond, Virginia. With a pair of wagons towing his equipment, Brady traveled with the army to Manassas, Virginia.

There, on July 21, 1861, Union troops collided with Confederates in the first major battle of the war. Though the blue-coated Northerners seemed to have the edge in the early part of the struggle, Confederate forces rallied behind General Thomas "Stonewall" Jackson. By mid-afternoon, thousands of Yankee soldiers were fleeing to Washington. Brady, who had actually captured a battle scene on a plate, was caught in the rout. "Our apparatus was a good deal damaged on the way back to Washington, yet we reached the city," he later noted.

To cover as many campaigns as possible, Brady hired a number of photographers, equipped them, and sent them to various locales. "I had men in all parts of the army," Brady said, "like a rich newspaper." He spent more than $100,000 outfitting his "Photographic Corps" and borrowed an additional $25,000 to keep it running.

The Confederacy also had cameramen in the field. George F. Cook of Charleston, South Carolina, had once worked for Mathew Brady. Louisiana photographer A. D. Lytle specialized in shooting pictures of Union lines, though he was sometimes the target of Yankee sharpshooters. Since the South had few factories to produce photographic materials, supplies were scarce and often had to be smuggled from Northern warehouses.

Brady's staff—Alexander Gardner, Timothy O'Sullivan, and others—had difficult jobs. Nineteenth-century roads were often rutted, muddy, and dusty. So photographers carefully packed and repacked glass plates, collodion, developing solutions, and delicate equipment as their wagons bounced along. Cracked glass plates were common. Wagons, windowless and painted black, were called "what-is-it wagons" by curious soldiers. Dark tents served as darkrooms. Since any light entering a tent could ruin the developing process, tents needed frequent mending.

Once photographers reached the battlefield, they went to work, setting up bulky cameras on tall tripods. In *Photography and the American Scene,* Robert Taft notes that the photographer's plate "had to be flowed with collodion, sensitized in his dark tent, hurried to the camera, exposed from ten to thirty seconds, hurried back to the dark tent for development and a new plate prepared."

On more than one occasion, bullets whistled by and shells crashed as photographers aimed cameras and prepared plates. A Confederate artillery shell once exploded next to cameraman Thomas C. Roche, but, as one observer noted, "shaking the dust from his head and his camera he quickly moved to the spot and, placing it over the pit made by the explosion, exposed his plate as coolly as if there were no danger, and as if working in a country barnyard."

Actual battles were rarely photographed. Exposing a plate took too much time—a picture would have showed only the blurred images of running soldiers. Instead, military photographers had to be satisfied with scenes of troops in camp, warships resting quietly in rivers, and rows of artillery. To millions of Americans at home, these stationary views were exciting images of war. Those images, however, were about to change dramatically.

"THE TERRIBLE REALITY"

On September 17, 1862, Confederate General Robert E. Lee's Rebel forces collided with a Yankee army near Antietam Creek in Maryland. Savage fighting erupted around Dunker Church, the Miller farm cornfield, and a small bridge soon to be called Burnside's Bridge. At a

narrow road later named Bloody Lane, the battle was especially fero-
cious. Hundreds of Rebel and Yankee soldiers died trying to seize the
position. By day's end, more than 20,000 men lay dead or wounded.

Within two days of the battle at Antietam, Alexander Gardner and
his assistant photographed the killing fields. Dead soldiers, bloated by
the hot September sun, were strewn near fences and in cornfields cut to
stubble by bullets. By October, the pictures were displayed in Mathew
Brady's New York gallery, and prints were on sale by November. These
were images Americans would not soon forget. "Mr. Brady has done
something to bring home to us the terrible reality and earnestness of
war," wrote one reporter for the *New York Times*. "If he has not brought
bodies and laid them in our dooryards and along the streets, he has done

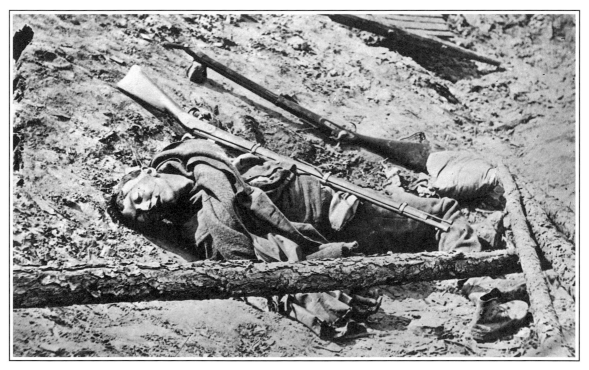

*Brady staff member Thomas C. Roche took this photograph of a dead
Confederate after the siege of Petersburg, April 1865.*

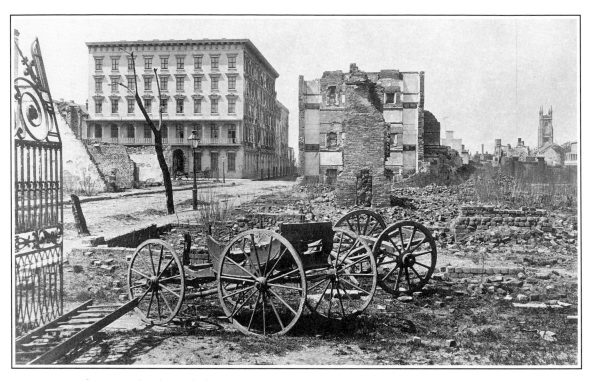

Photographs showed the devastation in cities such as Charleston, South Carolina, at war's end.

something very like it." Future grisly portraits would include the aftermath of battles at Gettysburg, Cold Harbor, and Petersburg.

Though Gardner and other photographers did the bulk of the picture taking during the war, Mathew Brady received much of the credit. Many photographs taken by his staff were reproduced as engravings or woodcuts in popular publications such as *Harper's Weekly* and *Leslie's Illustrated Newspaper.* Most illustrations carried a small notation: "From a photograph by Mathew Brady." Others, printed as carte de visites or in larger formats, also bore Brady's name. To receive credit for his own work, Alexander Gardner left Brady in 1863 and started his own photography business. Thousands of patrons visited the galleries of Brady, Gardner, and other photographers to view the latest pictures of the war.

The camera witnessed one of the more grim stories of the Civil War—an exchange of Yankee and Rebel prisoners at Confederate prison camps in Richmond, Virginia, and Andersonville, Georgia, in 1864. The South, short on supplies for its own soldiers, could hardly scrape enough food together for captives. Barely able to sit upright, the Yankee prisoners appeared in photographs as living skeletons. Photographs of dying prisoners were displayed in Northern bookstores, and engravings appeared in news magazines. The North boiled in shock and anger; Congress called for an investigation. "You cannot look with composure now upon the daguerreotypes of those men whose skeletons are before you," noted one congressman in January 1865. The power of those photographs helped condemn the commander of Andersonville to death after the war.

As the Civil War drew to a close in 1865, the camera recorded how the burden of conflict had changed Abraham Lincoln. The gangly presidential candidate jokingly pulling at his collar was gone. In a photograph taken by Alexander Gardner in April 1865, the president's face appeared gaunt, the lines creasing his cheeks a bit deeper. Though his eyes were shadowed by weariness, a faint smile seemed to touch his lips. The war had ended. Within days, however, Lincoln would be dead at the hands of an assassin. The camera captured somber images of the funeral train, the casket on its caisson, weeping crowds saying farewell.

In four years of fighting, nearly one million Americans had been killed or wounded. More than $15 billion had been spent by both governments. Historians estimate that more than a million images were produced by as many as 1,500 professional and amateur photographers during the war. Due to neglect and mishandling, many plates were later lost or damaged. The thousands that survived, however, showed a country changed forever.

AMONG PEAKS AND PRAIRIES

*On looking upon these pictures,
one can imagine himself among
the hills and mines of California,
grasping at the glittering gold that
lies before him.*

—*Daguerrian Journal*
correspondent, 1851

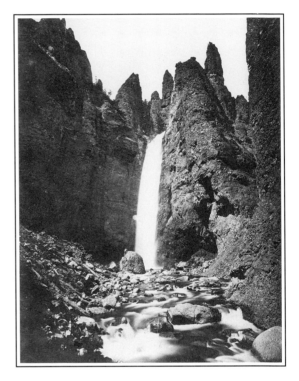

As the guns of the Civil War fell silent, thousands of Americans returned to the daily chores of family life, field, and factory. Northern iron and cloth mills went from producing weapons and uniforms to making consumer goods for a peacetime society. Confederate soldiers returning home found farms and croplands devastated by four years of war. Men and women from both regions began looking westward, hoping to start a new life on the great frontier. Much of what they knew about the West came from photographs. Vicki Goldberg states in *The Power of Photography,* "Photographers introduced Americans to their own

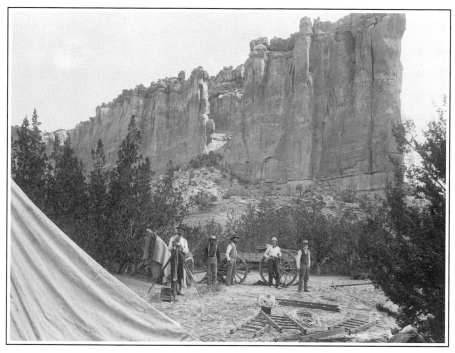

Adam Vroman and colleagues prepare to ascend Enchanted Mesa near the Acoma Pueblo in New Mexico. Opposite: Yellowstone's Tower Falls, photographed by William Henry Jackson in 1871

unknown land and their unexplored past: the West. The curiosity, admiration and yearning aroused by these pictures . . . magnified national pride at a time when the nation needed healing."

Exploration and settlement of the lands west of the Mississippi River had been going on for decades. But, at first, the only pictures of such lands were paintings and sketches by artists such as Asher Durand and E. Hall Martin.

When gold was discovered in California in 1849, many daguerreotypists went west to seek their fortunes. R. H. Vance took nearly 300 views of the goldfields and surrounding areas. Thousands visited his collection when it went on exhibit in New York City in 1851. Unfortunately, the exhibition was a financial failure, and Vance was forced to sell his plates.

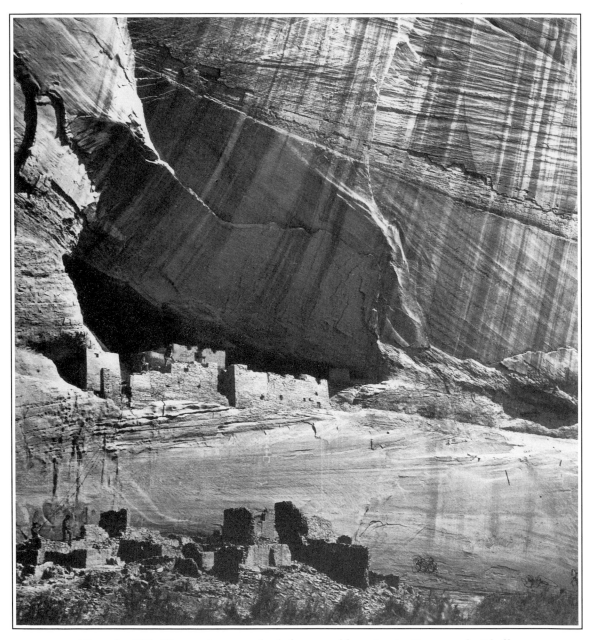

Timothy O'Sullivan photographed these pueblo ruins in Canyon de Chelly, Arizona.

Throughout the 1850s, surveyors and cartographers set out to map western lands and to find trails, wagon roads, and rail routes west to the Pacific Ocean. Daguerreotypists—since they could capture realistic images of the terrain—were hired to accompany surveying and mapping expeditions.

Photographers on the trail had to be specially prepared. Charles R. Savage had a wagon custom-built for his work. "It is about nine feet long and six feet high in the dark room, leaving three feet of space in front for carrying a seat and provisions," he wrote. "The sides are fitted with grooved drawers, for the different sized negatives, and proper receptacles for the different cameras, chemicals, etc., forming a very complete outdoor dark room." Though proud of his rig, Savage did admit that the wagon was "a little too heavy."

During Colonel John Fremont's expedition through the Rocky Mountains in 1853 and 1854, photographer Solomon Carvalho noted that taking a daguerreotype took from one to two hours, and "the principal part of that time was spent in packing, and reloading the animals."

"I succeeded beyond my utmost expectation in producing good results and effects by the Daguerreotype process, on the summits of the highest peaks of the Rocky Mountains with the thermometer at times from 20 degrees to 30 degrees below zero, often standing to my waist in snow, buffing, coating, and mercurializing plates in the open air," Carvalho wrote.

Weather was not the only danger westward-bound photographers faced. Sickness was common, and food and fresh water were usually in short supply. Timothy O'Sullivan, who joined a surveying team after the Civil War, complained of "voracious and particularly poisonous mosquitos," as well as dangerous fevers, while photographing in the Rockies.

Some cameramen—Ridgway Glover, for example—met their deaths at the hands of Native Americans who resented white trespassers on their traditional hunting grounds. Other photographers had more success with Native Americans. On a surveying expedition with Isaac I. Stevens in 1853, John Mix Stanley set up his tripod and camera near a Blackfoot

village on the Missouri River. "Mr. Stanley commenced taking daguerreo-types of the Indians with his apparatus," Stevens later recalled. "They are delighted and astonished to see their likenesses produced by the direct action of the sun." Other Native Americans were less eager to be pho-tographed. When cameraman Adam Vroman visited the Hopi and Zuni tribes of the Southwest in 1895, the Indians were extremely suspicious. Some believed that cameras were "shadow catchers," and that by captur-ing the subject's image, photographers could control his or her spirit.

"THE CAMERA TOLD THE TRUTH"

A student of R. H. Vance, Carleton Watkins journeyed to California's Yosemite Valley in 1861. White men had first visited the valley in 1833. A few artists' sketches had been published in the mid-1850s, but most Amer-icans were unfamiliar with Yosemite's awesome beauty. Watkins con-structed a special camera that held four-pound glass plates measuring 18 by 22 inches. He needed a 12-mule team just to transport his equipment. The labor was worth it, however. Watkins captured clearly defined images of the valley—the soaring mountain peak El Capitan, the thundering, 300-foot Vernal Falls, the majesty of ancient sequoia trees. His breath-taking work, reprinted on stereographs, became familiar to thousands.

By the mid-1860s, Americans were eyeing Yosemite for settlement. But some people, including several members of Congress, felt the val-ley's rugged beauty should be preserved. In the eastern United States, huge tracts of forest had already been cut to make room for towns and industry. Across the nation, land was being cleared for farming. Rail-roads were carrying settlers to virtually all areas of the continent. What would be left of America's beauty, people wondered, if every acre of ground was carved up for agricultural or industrial use?

A bill to protect Yosemite from development was introduced in Con-gress in 1864. Watkins' photos had a dramatic effect on the debate. One correspondent noted: "It has been said that 'the pen is mightier than the sword,' but who shall not say that in this instance, at least, the camera is mightier than the pen?" Upon viewing Watkins' work, lawmakers named

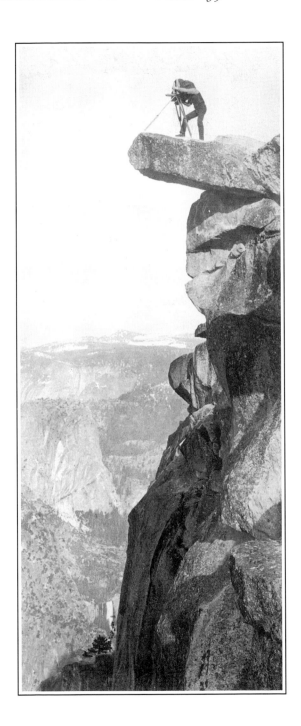

Western photographers such as William Henry Jackson—here at Glacier Point in Yosemite Valley—took many risks to get pictures.

Yosemite a protected area. The valley would not be opened to development; it would be preserved for the enjoyment of future generations.

Yellowstone Park, too, was preserved in part due to photographs. For decades, Americans had heard of the incredible wonders of the Yellowstone region in Wyoming Territory. There, geysers spouted from the ground, hot springs bubbled and steamed, rapids foamed as rivers tumbled through rocky canyons. Grizzly bears, elk, mountain sheep, and buffalo roamed prairies and forested slopes. After surveyors and photographers explored the area from 1869 to 1871, views of Old Faithful, Mammoth Hot Springs, and the Grand Canyon of the Yellowstone became familiar to millions of Americans.

Perhaps the most important survey of Yellowstone was led by F. V. Hayden in 1871. Accompanied by photographer William H. Jackson, the Hayden party studied the region's unusual geology. With nearly 200 pounds of equipment, most of it packed on his mule, Hypo, Jackson descended steep valleys and climbed cliffs to capture Yellowstone's staggering beauty. His photographs appeared in galleries and bookstores throughout the nation. When Hayden and others introduced a bill in Congress to set Yellowstone aside as a national park, Jackson's images were displayed and distributed to congressmen and senators. "Description might exaggerate, but the camera told the truth; and in this case the truth was more remarkable than exaggeration," wrote Yellowstone historian H. M. Chittenden. The government agreed. On March 1, 1872, President Ulysses S. Grant signed the bill creating Yellowstone National Park.

Jackson also shot photos of the jagged peaks of the Teton Range in Wyoming and the ruined cliff dwellings of Mesa Verde in Colorado. W. H. Illingworth of St. Paul captured scenes of Colonel George Armstrong Custer's caravan to the Black Hills of Dakota Territory. William Bell accompanied a surveying expedition in 1872 to Utah and Arizona territories. Though their photographs were important scientific and historical documents, they had broader effects. A writer for the *New York Times* noted: "While only a select few can appreciate the discoveries of the

geologists or the exact measurements of the topographers, everyone can understand a picture."

Stereographs and carte de visites depicting the wonders of the West flooded eastern markets. F. J. Haynes, a photographer for the Northern Pacific Railroad, calculated that he sold 540,000 stereoscopic views of western scenery. "Of 22 x 26 [inch] views of Mammoth Hot Springs, I have sold 8,000, and 30,000 more of 8 x 10 views of the same," Haynes

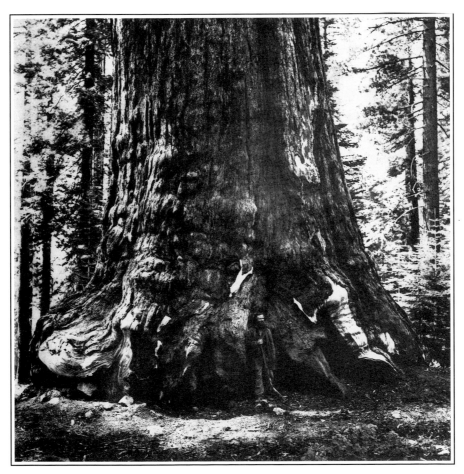

Pictures such as this—the Grizzly Giant sequoia tree photographed by Carleton E. Watkins—caused a sensation back east.

wrote. In 1870, on Chicago's State Street, more than a dozen stores displayed photos in colorful boxes or spread them out on blankets. Ralph Andrews writes in *Picture Gallery Pioneers:* "The people bought and bought with a suddenly awakened hunger for famous faces and faraway places."

Photographs only exposed Americans to these faraway places. But the promise of a new life lured millions to see the West firsthand. Gold was discovered in Colorado in 1858 and in Dakota's Black Hills in 1874. In 1889, parts of Oklahoma Territory were parceled out to settlers. Throughout the last half of the 19th century, wagon trains snaked west to the Pacific over long, dust-choked paths dubbed the Oregon Trail and the Santa Fe Trail. On May 10, 1869, America's east and west coasts were linked by railroad at Promontory, Utah, in a scene made famous by photographers Charles R. Savage and Andrew Russell.

FOLLOWING THE RAILROADS

As the railroads crawled and clawed their way across western America, towns sprang up in their wake. Cattlemen, tourists, farmers, and merchants now had an easy way to travel and transport goods. Newcomers hoped to catch a glimpse of the cowboys, outlaws, and Indians glamorized by fictional "dime novels." The West seemed exciting and romantic, and it could be easily reached by rail.

Railroad owners were quick to realize the power of photography—it enticed settlers and tourists to ride trains. Scenic photographs were proudly displayed "in the largest Hotels on the line of the Central Pacific Railroad, and from San Francisco to Chicago," read an advertisement for the Central Pacific. The Northern Pacific went a step further—it hired F. J. Haynes to travel its routes in a decorated Pullman passenger car. Fancy gilt letters along the top of the car advertised "Haynes Palace Studio." Arranged inside were darkrooms, furniture, cupboards, a stove, and a six-barrel water tank. Haynes not only took portraits of railroad passengers but also captured images of farmers at work, western streets, and hunting parties displaying trophies of wild game.

Some photographers set up permanent galleries in frontier towns. "Get

your picture taken before you die or look worse," read an ad for Colorado photographer A. S. McKenney. Other photographers traveled, taking pictures of western settlers outside their crude log cabins and sod houses. Glass for windows was scarce on the frontier, and interiors were too dark for picture taking. So to show off their prized belongings, settlers sometimes dragged pump organs, pianos, artwork, rocking chairs, and dining room sets (all hauled west by wagon) outdoors to be photographed with the family.

SCENES OF DAYS GONE BY

At times the camera peeled away the West's romantic image. Photographer Andrew Forbes bounced along on buckboard and muleback through Oklahoma and Texas, hoping to capture pictures of the real

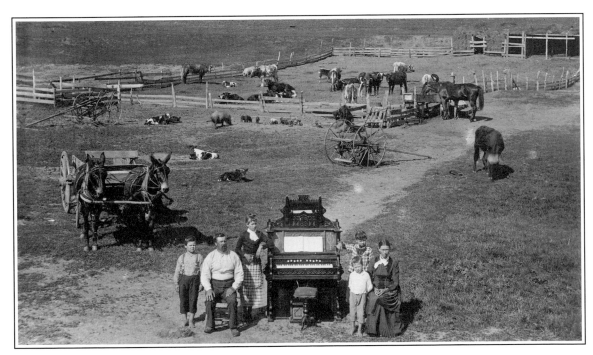

These Nebraska pioneers made sure that their cherished organ—but not their makeshift sod house—appeared in the family photograph.

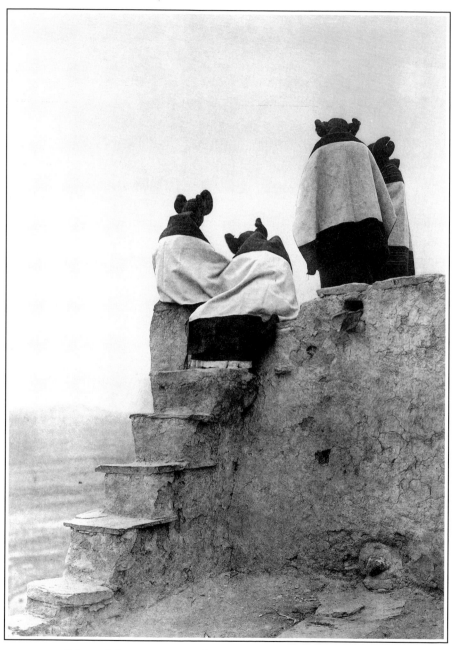

Edward S. Curtis: **Watching the Dancers—Hopi,** *1906*

American cowboy. But he found that few cowboys resembled the rugged heroes of dime novels, guns strapped to their hips. As Karen Current relates in *Photography in the Old West,* "The [cowboys] are rarely seen as tall and lean in the saddle, but rather as a motley assortment of men of all ages and descriptions."

Native Americans, too, seemed much more exotic in fiction than they did in photographs. During the period of westward expansion, the U.S. Army slaughtered many Indians and forced others onto reservations, where traditional practices were often banned. Many photographers wanted to document a fading Indian culture. The best known of these photographers, Edward S. Curtis, toured the West for 30 years, shooting pictures of Indians, usually dressed in traditional costumes and posed with tools and weapons. Though most of Curtis's photos were staged, they nevertheless serve as an important record of Indian life.

Laton Alton Huffman recorded images of Native American leaders and of vast prairies before they were hemmed off by barbed wire fencing. "Round about us the army of buffalo hunters—red men and white—were waging the final war of extermination upon the last great herds of American bison seen upon this continent," Huffman recalled. He continued:

> Then came the cattleman, the "trail boss" with his army of cowboys, and the great cattle roundups. Then the army of railroad builders. That—the railway—was the fatal coming. One looked about and said, "This is the last West." It was not so. There was no more West after that. It was a dream and a forgetting, a chapter forever closed.

Ironically, the Old West continued to live on via the pictures of Huffman and other frontier photographers. Their photographs remained in great demand and were printed as postcards, murals, handtinted enlargements, and engravings to illustrate books. As the real Wild West faded, the myth of the West—preserved in nostalgic photographs—grew larger.

ALL EYES ON THE BIRDIE

McKenney, photographist, has cameras and other appliances that will take a handsome picture of the ugliest man or woman . . . and make them look absolutely lovable.

— photographer's advertisement, about 1870

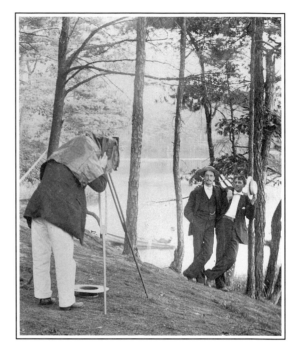

In 1863, G. C. Spinner, the treasurer of the United States, sent an apologetic note to a distant friend. "I wish I could spend a few days with you in New York, but that is quite out of the question," Spinner wrote. "But as I cannot come myself, I enclose you the 'counterfeit present-ment.'" Inside the letter, Spinner included his photograph.

Before the Civil War, family members often stayed together from birth until death, living within the same community—sometimes even under the same roof. But after the war, as railroads crisscrossed the western plains, new opportunities began to separate families. A son or daughter might move to the goldfields of Dakota Territory or the growing me-tropolis of San Francisco. Years might pass before families were reunited.

To preserve the family group, many people turned to photographs.

Portraits of absent children, grandparents, and siblings were framed and hung in parlors or displayed on easels. Carte de visites were carried in vest pockets. Grieving family members even called on photographers to preserve images of the dead.

This custom, called postmortem photography, appeared in the 1840s, grew in popularity in the 1880s, and remained common into the early 20th century. Medical knowledge was limited in the mid-19th century, and many medicines were ineffective. Deadly diseases often struck the youngest and frailest family members; many people died in childhood.

Most postmortem photographs were of children, often posed on a couch with a favorite toy or on their mothers' laps. Albert Southworth and Josiah Hawes specialized in postmortem images. "We take miniatures of children and adults instantly, and of Deceased persons either at our rooms or at private residences," read their advertisement. Southworth recalled:

Photographs of the dead, especially dead children, were quite common in the late 19th century.

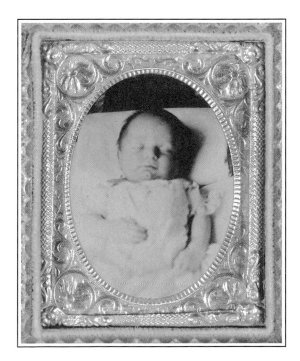

> If you work carefully over the various difficulties you will learn very soon how to take dead bodies—arrange them just as you please . . . the way I did to have them dressed and laid on the sofa, just lay them down as if they were in a sleep, that was my first effort You may do just as you please as far as handling and bending of corpses is concerned. You can bend them until the joints are pliable and make them in a natural and easy position.

As medicine and medical care began to improve in the early 20th century, deaths among children declined, and the practice of postmortem photography faded.

The camera recorded happy occasions too. As early as 1840, the Yale College class of 1810 gathered for a portrait recording its 30th reunion. Group photos of West Point graduates of the 1850s reveal future officers of both the Union and Confederacy. Early baseball teams posed for pictures. Mens' and womens' rowing teams posed in their uniforms. Later, football players in padded jerseys gathered around their mascot or a recently awarded trophy for a group picture. Photographers directed groups to look straight at the camera without moving. "Keep your eyes on the birdie," they told adults and children alike, motioning to a toy bird perched above the camera.

By the 1860s, photography had even affected dating. "There is a practice, quite prevalent among young ladies of the present day which we consider . . . very improper," scolded Jane Grey Swisshelm, editor of the St. Cloud (Minnesota) *Democrat.* "We allude to their giving daguerreotypes of themselves to young men who are merely acquaintances. . . . We are astonished that any young girl should hold herself so cheap as this." Swisshelm advised that if a young woman was engaged to be married, it was fine to present a card photograph to her man. If the couple broke up, however, he should return her portrait. Swisshelm was probably just as shocked by a growing fad of the era—that of advertising in the newspaper for a suitable husband or wife. Ads often requested that a prospective spouse send a daguerreotype or carte de visite along with a written reply.

Marriage, of course, was another milestone that begged to be captured by photographers. Early cameras were unable to record sharp contrasts between light and shade. Dark, drab colors showed up best in photographs, and brides were directed to avoid white, light blue, and pink gowns. Photographer Augustus Washington's studio was noted as "perhaps the only one in the country that keeps a female attendant and dressing room for ladies. He recommends black dresses for sitting." Photographer Cuthbert Bede wrote a warning to brides: "Photographs of people in white dresses would appear to be the portraits of as many ghosts."

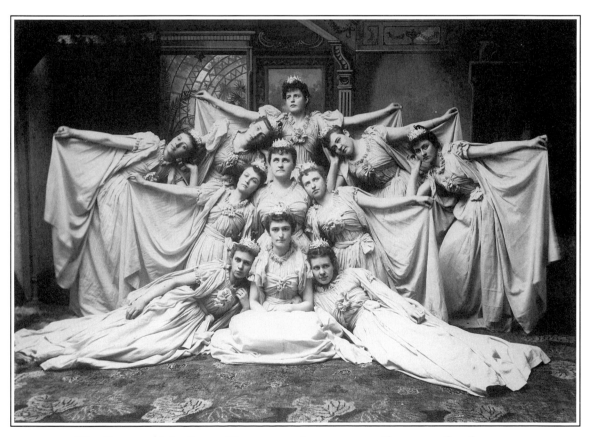

The Queens of the Sea, a Vermont acting troupe, strike a pose for the camera.

Both daguerreotype and wet-plate cameras required lots of sunlight, so photographing an indoor ceremony in a church lit by lanterns or candles was nearly impossible. Prior to the 1880s, portraits of bridal parties were relatively uncommon. Usually, just the bride and groom posed for the camera in dark-colored street clothes. Some album and frame companies printed colorful marriage certificates with press-out ovals where carte de visites of a bride and groom could be inserted.

At first, people kept card photographs and tintypes in wicker baskets in the parlor. But handling and exposure to light dulled many images. So Americans were soon buying photograph albums, which protected images and made them easy to view. Vicki Goldberg states in *The Power of Photography:* "Cartes by the dozen could be slipped between covers—

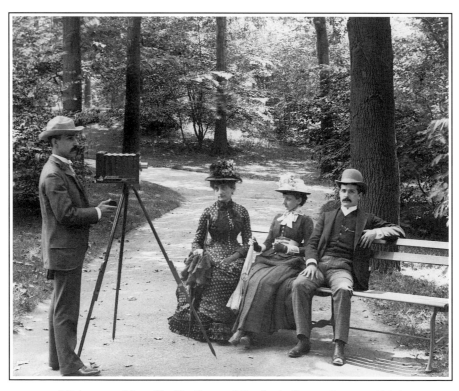

Visitors to New York's Central Park sit for a picture, 1885.

fifty not an unusual number of spaces in an album—and displayed for visitors. Every front parlor became a kind of private gallery in miniature." Albums came in many sizes and styles. Some were elaborately bound in leather, with graceful wood or metal carvings inlaid on the cover. Others were cloth-covered cardboard folders without frills. Prices ranged from a few dollars to more than fifty.

While portraits of loved ones were cherished possessions, portraits of celebrities, actors, and heroes were exciting collectibles. Americans collected carte de visites of the famous and infamous alike—from Civil War generals to outlaws—as well as stereographs of exotic places. As collections grew, people began trading card photos, much like 20th-century children trade baseball cards.

One popular card carried the picture of abolitionist Sojourner Truth. A former slave, Truth gained fame in the 1840s when she fearlessly spoke against slavery. During the Civil War, Abraham Lincoln welcomed her at the White House. Though Truth was illiterate, a friend helped her write an autobiography, which she sold during preaching tours. After an illness in 1863, Truth ran out of books to sell. Low on funds, she had her portrait taken, hoping photographs would sell faster than her autobiography. She was correct. A Falls River, Massachusetts, newspaper reported:

> Sojourner Truth . . . is spending a few days in our city. . . . Give her a call, and enjoy a half hour with a ripe understanding, and don't forget to purchase her photograph.

Smelling money, photographers competed for the rights to photograph famous people. At first, celebrities posed for portraits free of charge. That changed, however, when English writer Charles Dickens toured the United States in 1867 and 1868. Dickens refused to pose unless photographers paid him a fee. Later, actress Sarah Bernhardt received $1,500 for her theatrical poses. English actress Lillie Langtry demanded $5,000.

By the late 1860s, card photographs and tintypes were losing their novelty. Many photographers switched to a larger format: a 4-by-5½-inch photo mounted on a 4¼-by-6½-inch card. Dubbed cabinet photos,

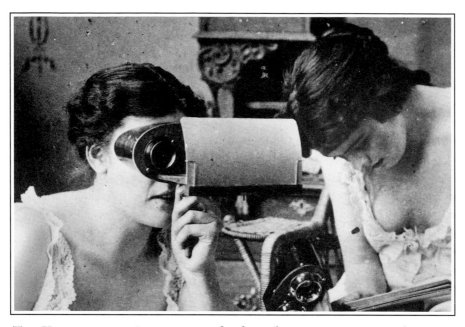

Top: Young women view stereographs through stereoscopes, around 1900.
Bottom: Like many scenic pictures, Carleton Watkins' 1870 photograph of
Multnomah Falls in Oregon was printed and sold as a stereograph.

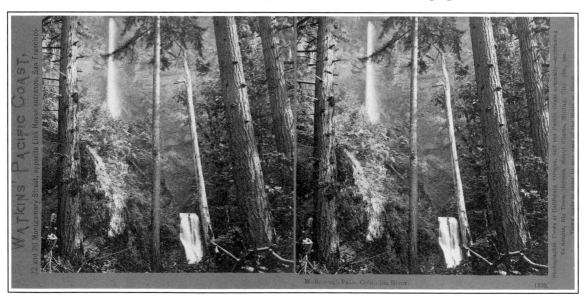

the larger pictures could easily be framed and displayed on a mantle, table, or wall. Photographers working with a larger plate could also pay more attention to lighting, posing clients, and providing more elaborate backgrounds. One New York photographer's studio boasted of "more than fifty painted backgrounds, representing sea and sky, plains and mountains, tropic luxuriance and polar wastes; every style of scenery from Egypt to Siberia."

DRY-PLATE BREAKTHROUGH

Taking photographs was not nearly as pleasant as looking at them. Photographers of the era struggled with heavy plates, unwieldy cameras, and sticky collodion. That changed in the 1880s, when the gluey collodion plate was largely replaced by a new invention. Dr. Richard Maddox, an English physician, found that a coating of gelatin and other chemicals could capture images on glass plates even when dry.

Maddox's discovery revolutionized photography. With the wet collodion formula, each plate had to be coated, rushed into the camera, then immediately developed in a darkroom. Most photographers were professionals willing to lug around numerous chemicals, plates, and heavy cameras. With the gelatin dry-plate process, photographers could prepare plates beforehand and store them until needed or purchase prepared dry plates from a factory. After shooting a picture, the photographer didn't need to hurry it into the darkroom, but could wait and develop the image at a later time.

What's more, dry plates recorded images in less than a second of exposure time. Cameras had improved too. Newly developed shutters, operated by a squeeze bulb and a tube, let into the camera the precise amount of light needed to expose the plate. The process was so quick that photographers could take crisp pictures while holding cameras in their hands. The days of mounting cameras on motionless tripods and counting the precise seconds needed for exposure were over. Shooting pictures with gelatin dry plates was so simple that one expert believed "a person of average intelligence could master it in three lessons."

Previously, subjects had to stay very still during exposure or an image would blur. But the dry-plate and shutter system was so fast that photographers could snap clear pictures of moving trains, people walking, even three tennis balls thrown into the air at once. To Americans of the era, photographs of objects in motion were seen as practically miraculous.

K STANDS FOR KODAK

The introduction of the dry-plate system created a great demand for factory-prepared plates. Among the businessmen who responded to this demand was a former bank clerk from Rochester, New York, named George Eastman. In 1881, Eastman invested $3,000 into dry-plate manufacturing. Though he had some difficulties at first, in two years he turned a profit of $30,000. Business was so good that he was able to build a new factory, complete with electric lights.

Eastman was not satisfied, however. Dry plates were still made of glass and required special preparation and developing. The photographer still had to insert a bulky plate in the camera to take each picture and had to remove the plate afterward. If pictures could be captured on lightweight, gelatin-coated film instead of glass, Eastman reasoned, photography would become more simple. And since images from gelatin-coated negatives (unlike collodian negatives) could be enlarged, small pieces of film could be used to print big pictures.

Eastman devised a method for capturing one image after another on a long piece of gelatin-coated film, rolled around spools inside the camera. After shooting a picture, the photographer simply turned a knob that wound the spools and positioned an unexposed section of film before the camera's lens.

In 1888, Eastman began marketing his new lightweight (22-ounce) camera, complete with rollers and flexible film. For $25, a customer could purchase a camera with a 100-exposure roll of film inside. Once the roll was used, customers sent the camera to a photography shop or to Eastman's factory for development and reloading. Within two or three weeks, customers received their finished pictures.

George Eastman poses with a Kodak camera aboard the SS Gallia, 1890.

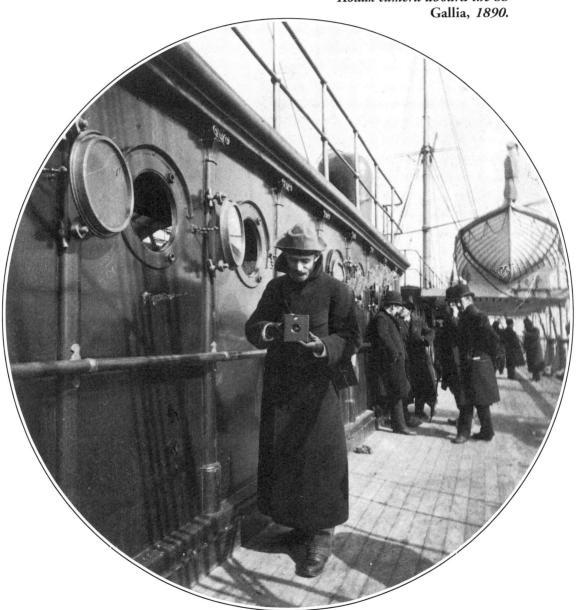

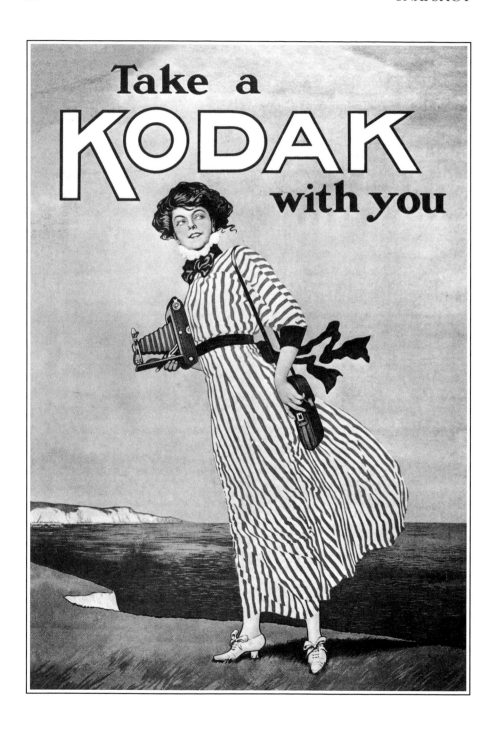

Eastman's cameras were an instant hit. He wanted Americans to recognize his cameras and equipment immediately, so he invented a brand name—Kodak. What did it mean? Absolutely nothing. According to Robert Taft in *Photography and the American Scene,* Eastman chose to start his company name with a *k* because it seemed a "strong, incisive sort of letter." He tried out various combinations of letters until he hit upon a word that was short, easy to pronounce, and very distinct.

The Kodak camera kit included three simple instructions: "1. Pull the String, 2. Turn the Key, 3. Press the Button." The instructions went on to note, "it is now easy for any person of ordinary intelligence to learn to take good photographs in ten minutes. Not simply to take one picture . . . but to repeat it over and over again with such accuracy as to average over eighty-five per cent good pictures from the start."

Eastman coined a slogan for his business: "You Press the Button, We Do the Rest." An 1892 song praised Eastman's invention:

> Isn't it simple? Isn't it quick?
> Such a small box, it must be a trick!
> How do you work it? What is the test?
> You press the button; we do the rest.

Kodak ads featuring attractive young women with cameras inspired another musical hit, William Cramel's "The Kodak Girl," and in 1908 Harry Lincoln wrote "The Focus," music for orchestra and dance. The sheet music cover featured a Valentine's Day cupid with a camera and tripod.

Finally, photography was no longer a mystery, nor a pursuit for professionals only. Millions of ordinary Americans purchased simple box cameras such as Kodak's Brownie model and began photographing family, friends, possessions, and scenery. The Delmar camera firm offered to send a sample picture to prospective buyers. The Truphoto company's slogan was "They Get the Picture."

The new cameras were easy to use but had a few drawbacks. In the early years, Kodaks had no viewing device to help users position images before the lens. Amateur photographers tended to aim their cameras

haphazardly, much like hunters who shot quickly without aiming. These hunters were called "snapshooters," and amateur photographers soon earned the same nickname. Their often off-center photographs were called "snapshots."

With flexible film and easy-to-use cameras, scientific study improved. Doctors, botanists, meteorologists, and other professionals used photographs to document their work. In the early 1890s, American explorer Robert E. Peary took a Kodak with him as he tramped and camped among the icy mountains of Greenland, trying to reach the North Pole. Though he wouldn't reach the pole until many years later, he nevertheless snapped more than two thousand pictures of the Arctic region. Peary was not a professional photographer, but his photos were clearly defined and presented an accurate visual record of his expeditions. Just a generation earlier, not even a professional photographer could have made so many photographs in such harsh terrain.

FOR PLEASURE AND PROFIT

In 1897, Francis Benjamin Johnston penned an article for *Ladies' Home Journal.* Titled "What a Woman Can Do with a Camera," the article underscored Johnston's belief that women could use cameras as capably as men. "The woman who makes photography profitable," she noted, "must have good common sense, unlimited patience to carry her through endless failure . . . good taste, a quick eye, and a talent for detail."

Like Johnston, several thousand women were working as professional photographers by the turn of the century. Tens of thousands more enjoyed amateur photography. In 1900, one news writer asserted: "The woman who does not understand the use of the camera . . . is an exception." Johnston spent many hours instructing women on the finer points of photography. As a photographer herself, she took pictures inside the White House under five presidential administrations. In some of her most notable work, she captured images of classrooms, teachers, and students.

Not only were women enjoying photography during this era, they were

also engaged in another new pursuit: bicycling. Cameras had become so small and lightweight that they could be easily packed while pedaling. Both photography and biking, according to Naomi Rosenblum in *A History of Women Photographers,* "were commended as healthy pastimes for men and women." Magazine and newspaper articles noted the "endless varying incidents and delights that the cyclist with a camera might encounter" and "promised a pleasant social life through clubs devoted to the sport."

Even more delightful, it seems, was taking secret photographs of unsuspecting subjects. During the 1890s, miniature cameras, costing as little as three dollars, were hidden in hats, watches, canes, even vest buttons.

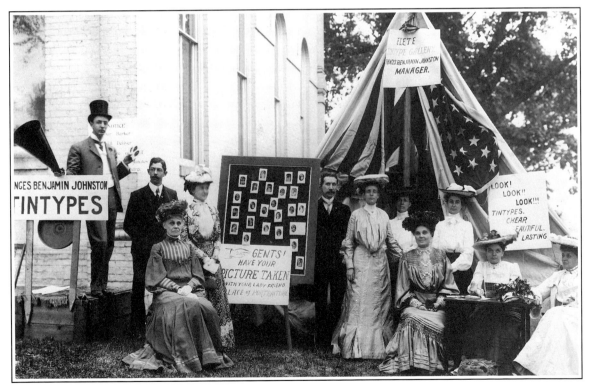

A tintype booth at a county fair in Virginia. The proprietor, Francis Benjamin Johnston, encouraged women to become photographers.

Named "detective cameras," the tiny inventions could be worked when asking a stranger directions or the time of day. "Ours is a practical secret Camera that defies detection," read an ad for a camera hidden in a hat. "It is worn with comfort, and is always ready for use."

Other people took their picture taking more seriously. Camera owners formed clubs such as the Society of Amateur Photographers and, later, the Camera Club. In journals such as the *American Amateur Photographer* and *Camera Notes,* professionals and amateurs alike learned about new techniques and artistic styles. In 1902, Alfred Stieglitz, Edward Steichen, and other American photographers formed a group called the Photo-Secession, dedicated to the promotion of photography as an art form. They organized photography shows across the United States and lent collections of photographs to exhibitors.

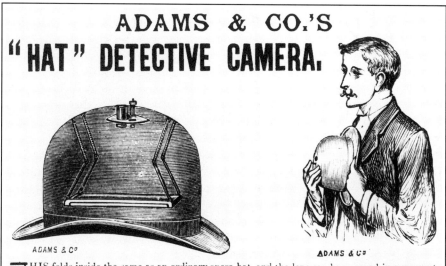

British advertisement, 1891

November 1922 issue of **Camera Craft,** *a photographers' journal*

"I always wanted to draw and paint," said Steichen, " . . . but could not draw well enough to satisfy myself. So when dry plates and push buttons came into the market I bought a box camera and began pushing the button." Steichen photographed people and objects with sharp and brilliant detail. In his portrait of powerful millionaire J. P. Morgan, light and shadow combined to create the impression that Morgan was clutching a dagger instead of the arm of his chair.

Industrialists like Morgan were growing stronger. Poor immigrants were flocking to the United States, willing to take factory jobs at the lowest wage. A less pleasant vision of America was appearing—and photographers would capture that too.

THE CAMERA AT WORK

In the early days of my child labor activities I was an investigator with a camera attachment . . . but the emphasis became reversed until the camera stole the whole show.

—photographer Lewis Hine

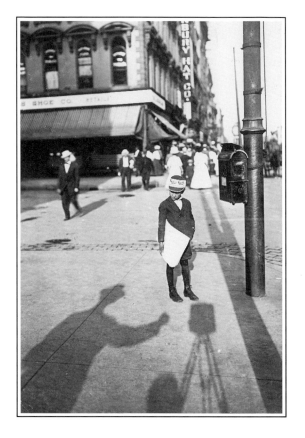

Jacob Riis arrived in New York City from Denmark in 1870. Like many other immigrants to America, he was unable to find a steady job. Poor to the point of nearly starving several times, he took up residence in the only place he could afford—a New York slum.

In the late 19th and early 20th centuries, European immigrants like Riis landed in New York by the shipload. Housing was in short supply, and most immigrant families could not afford decent places to live. To ease the apartment shortage, developers built seven- and eight-story brick apartment houses on narrow lots. Four apartments fit in each story.

Known as tenements, these living spaces were small, poorly ventilated, and terribly hot in summer. Usually, each floor had only one bathroom for all the residents, and often the plumbing did not work well. Disease and crime were widespread. By 1900, more than 40,000 tenements crowded Manhattan Island alone.

In 1877, Jacob Riis managed to find employment as a reporter for the *New York Tribune.* He specialized in crime and police activities, and much of his writing dealt with slum life, a topic he knew firsthand. Though Riis reported on slum problems, he felt his words and drawings could not truly show the public the awful living conditions of the poor. In 1888, he learned how to use a camera. He also learned to use a newly developed flash powder that enabled photographers to take pictures indoors and at night. Made of magnesium granules, the powder was sifted into a pan, then ignited with a match. Exploding with a roar and a bitter, burning smell, the powder illuminated Riis's subjects: dirty, dark sleeping rooms near the city dump and dingy alleys canopied by strings of laundry stretching from tenement to tenement.

One of the worst slums Riis visited was Mulberry Bend, a series of reeking, filthy tenements overcrowded with poor workers and villainous gangs of bullies. There, sleeping spots rented for five cents a night. Theft and assaults were common. Riis presented a report on the slum to New York's health board. "When the report was submitted. . . it did not make much of an impression," he noted, "these things rarely do . . . until my negatives, still dripping from the dark-room, came to reinforce them." Thanks in large part to Riis's photos, city officials took action. New York tore down Mulberry Bend, replacing it with a park.

In 1890, Riis published his first of several books: *How the Other Half Lives: Studies Among the Tenements of New York.* By this time, photographs could be printed in newspapers, magazines, and books via the halftone process. Halftones are photographs converted into a series of black dots. The dots and the white spaces surrounding them vary in size, depending on the tones of the original photograph. When printed, the dots merge and appear to create various shades of gray. Combined with

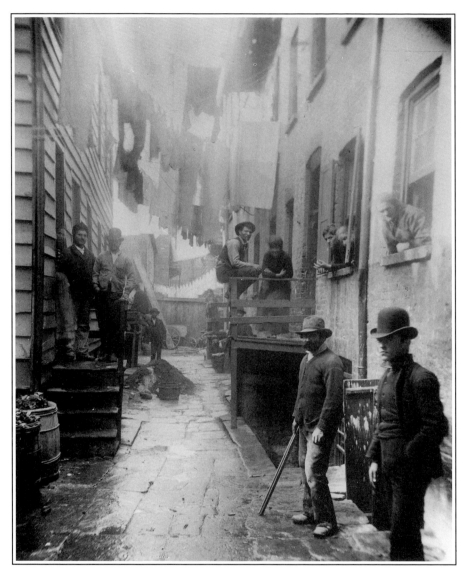

Jacob Riis: **Bandit's Roost, 39½ Mulberry Street,** *1888*

new, high-speed printing presses and improved film capable of translating all colors into gray tones, the halftone process enabled reporters to highlight their articles with photographs.

Riis's images shocked the public and brought about reforms. He had created a new style of photography—documentary photojournalism. As one leading journalist of the era observed: "The photograph is not the newest but it is the most important instrument of journalism which has been developed since the printing press."

FOCUS ON CHILD LABOR

Born in Wisconsin and trained as a teacher, Lewis W. Hine moved to New York City in the early 1900s. There, he took up photography and in 1904 began to photograph the flood of arrivals at Ellis Island, New York's immigrant processing center. He continued to photograph the newcomers—particularly children—at their jobs and tenement homes.

His work soon caught the attention of the National Child Labor Committee, which in 1907 appointed him to document the conditions of child laborers around the country. According to the national census, nearly two million children ages 10 to 15 were employed in 1900, many in dangerous occupations. From 1909 to 1916, Hine traveled to all areas of the United States to investigate child labor.

In the South, Hine found children sweating in cotton fields for 10 to 12 hours per day. Girls as young as eight often stood on tiptoe to change spools on giant machines in textile factories. In Baltimore and California, children of all ages labored in canneries. In Wisconsin and New England, youngsters waded into chilly cranberry bogs to harvest fruit. Perhaps the dirtiest and most dangerous job was breaking coal. *A Child Labor Bulletin* of 1913 described the process:

> Then the pieces rattled down through long chutes at which the breaker boys sat. These boys picked out the pieces of slate and stone that cannot burn. It's like sitting in a coal bin all day long, except that the coal is always moving, clattering and cuts their fingers. Sometimes the boys wear lamps in their caps to help them see through the thick dust. They bend over the chutes until their backs ache and they get tired and sick because they have to breathe coal dust instead of good, pure air.

Hine was careful to document his subjects. He recorded their names and ages whenever possible. He lied his way into factories and mines if he had to, posing as a worker or telling managers that he'd come to inspect equipment or sell insurance. If he wasn't allowed in, he would sometimes meet and photograph children at the factory gate when they came to work at 5 A.M.

Hine's photographs aroused the nation. "They speak far more eloquently than any work—and depict a state of affairs which is terrible in its reality—terrible to encounter, terrible to admit that such things exist in civilized communities," wrote an Alabama reporter in 1911. Concern for childrens' health, education, and welfare eventually caused the government to pass laws limiting the number of hours that children could

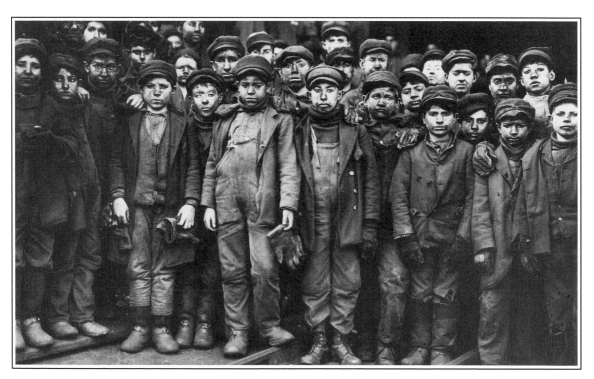

Breaker boys at a Pennsylvania mine, photographed by Lewis Hine in 1911

work and setting a minimum age for workers. Hine's photographs fueled these reforms.

Both Riis and Hine displayed their photographs and gave lectures in auditoriums jammed with people. To highlight the photographs and make them visible to the entire audience, Riis and Hine projected the images using "magic lanterns." The grandfather of modern slide and filmstrip projectors, a magic lantern had a metal or wooden body, a glass lens, a chamber to hold artificial light—oil lamps at first and later electric lamps—and a clamp to hold slides (photographs printed on transparent film instead of paper). The lens magnfied the image, and the light source projected the image onto a white wall or cloth screen.

Riis's presentations sometimes included up to 100 slides depicting the horrors of tenement life. Narrating with a dramatic voice, he soon had people in the audience crying, fainting, even talking to the screen. (Surprisingly, Riis never really considered himself a photographer. By 1898, he had set aside his camera to concentrate on writing. Upon his death in 1914, few obituaries mentioned his photographic skills.)

THE SCENE OF THE CRIME

When the gun smoke cleared from the Northfield, Minnesota, streets in 1876, outlaws and townsfolk alike lay dead. The dreaded Jesse James gang had robbed a bank, but the outlaws had met a storm of gunfire as they attempted to escape. Angry citizens displayed several dead gang members in open coffins as a warning to other outlaws. Photographers sold more than 50,000 souvenir prints of the deceased criminals to tourists, bookstores, and newspapers.

Though James himself was not killed in the shoot-out, his photograph was printed on posters and distributed across the nation. "Reward $20,000. Wanted Dead or Alive! Notorious Badman Jesse James," the posters read. Citizens who recognized the outlaw's face were instructed to "immediately contact the nearest U.S. Marshall's Office."

Identifying people with photographs was not a new idea. In 1861, season ticket holders riding the Chicago and Milwaukee Railway were

issued a type of passport with a photograph affixed. In 1858, New York City borrowed a French idea and established a "rogues' gallery" of criminals. Law-breakers were photographed, and their images were placed on file for future reference. By the 1880s, the rogues' gallery had become a tourist attraction: "Strangers from all parts of the country . . . came far to see it, and esteemed it a privilege to be permitted to do so."

Upon the murder of Abraham Lincoln, a massive manhunt began for the assassin, stage actor John Wilkes Booth, and his accomplices. Photographs of Booth were printed on wanted posters. But not everyone hated the killer. A few Southerners, their homes and livelihoods destroyed by Lincoln's armies, even cheered the president's murder. General Lewis Wallace, fearful that photographs would help make Booth a martyr among Southerners, banned the images. "The sale of portraits of any rebel officer or soldier, or of J. Wilkes Booth, the murderer of President Lincoln, is forbidden hereafter in this department," Wallace ordered. "All commanding officers . . . are hereby ordered to take possession of such pictures where ever found exposed for sale."

Booth was eventually shot by federal agents. The remaining conspirators were arrested, and Alexander Gardner was commissioned to photograph the prisoners. He took frontal and profile pictures of each of the accused before they were hung. Photographing criminals from these two views soon became standard law enforcement practice.

By the turn of the century, the camera had been put to work photographing crime scenes. Initially, surroundings mattered little to photographers and police. Photographers snapped pictures strictly to record the image of the victim. If furniture was in the way, the photographer would move it. On occasion, victims were also moved to present a clearer view. Repositioning bodies was an accepted part of a photographer's job. During the Civil War, some cameramen moved the dead or even placed a corpse's hand around a rifle to improve the scene. When a dam burst and flooded Johnstown, Pennsylvania, in 1889, photographers posed some of the two thousand dead to make their pictures more heart wrenching.

Much later, in the 1930s, photographing crime scenes became a standard part of police work. The invention in 1930 of the flashlamp, which lit a scene without exploding magnesium powders, made it easier to take pictures indoors. Photos were used to identify victims, help establish a motive, and define the relationship of the body to weapons or other items in the vicinity. Bodies and furniture were no longer moved. Courts studied photographs of crime scenes and accepted them as evidence.

EYEWITNESS

In 1914, World War I erupted in Europe. Trenches were gouged across the face of France and Belgium. Millions of soldiers died amidst the filth and horror of trench warfare. In 1917, the United States entered the war. As young men shipped out for Europe, songwriters stirred American passions with patriotic numbers like "When I Send You a Picture of Berlin."

American newspapers and news agencies, as well as the U.S. Army Signal Corps, immediately sent photographers to record the exploits of young American "doughboys" on the battlefields. Photographers quickly found they had to adopt a soldier's mentality to survive. One young cameraman, Albert Dawson, described his battlefield clothing: "One suit of heavy waterproof material with lots of pockets, marching shoes, and leather leggings, woollen-shirt, soft-felt hat, overcoat and gloves completed my clothing outfit. Bright colors must be avoided, gray and brown I found to be most practical." Dawson carried his camera and his stock of film in a case on his back.

The United States was a late entrant into the war. By 1917, British and French photographers had already purchased most of the cameras and photographic equipment in war-torn Europe. When the Americans arrived, they found a shortage of film, cameras, and lenses. Photography magazines in the United States ran ads begging civilian photographers for supplies. "Are You One of Those Reluctant Ones?" declared one headline. "It Is Your Patriotic Duty to Offer Your Lenses to Your Government."

Photos from the front lines depicted artillery, soldiers in trenches, and scenes of blasted churches and villages. Infantrymen were often posed

World War I aviators took pictures of enemy positions from the air.

with their weapons as if ready to attack the enemy. But photographers were warned by the army's high command that photos showing dead and mangled Americans would be strictly censored. Officers realized that the cold eye of the camera might be *too* truthful. The military did not want to alarm people back home.

Few photos actually showed combat. One U.S. general explained:

> In raids and advances, every advantage is taken of poor light conditions and although the photographers have taken many chances, and several have been wounded . . . little success has been attained in action pictures. When conditions are good for fighting they are, of necessity, poor for photography and vice versa.

Science and destruction walked hand in hand during World War I. New weapons such as tanks, submarines, airplanes, and poison gas were introduced. Even the camera became a weapon of war when mounted on aircraft and used to photograph enemy cities and troop positions. Officers studied aerial photographs when planning attacks, bombings, or bombardments with heavy artillery. Edward Steichen, a leading army photographer, later reported that "at least two thirds of all military information is either obtained or verified by aerial photography." Some experts considered a camera mounted on an airplane more deadly than a machine gun.

A camera attached to a hot air balloon photographed the South Dakota landscape from more than 13 miles up in 1935.

When peace returned in 1918, aerial photography proved its worth in mapmaking. By studying aerial photographs, cartographers, surveyors, and engineers could record land contours, elevation, and drainage patterns. The process was called photogrammetry.

Scientists in all fields put photography to work. Cameras affixed to giant telescopes recorded images of the sky and stars. In 1905 astronomer Percival Lowell noted that a mysterious gravitational pull—perhaps from an unknown planet—seemed to be affecting the orbits of Neptune and Uranus. From his observatory in Flagstaff, Arizona, Lowell focused a camera on the night sky. Week after week for years, he took pictures of the heavens. He studied the photographs, noted the planets' movements, and made calculations. It wasn't until 1930 that astronomer Clyde Tombaugh, using Lowell's data plus more advanced photographic technology, captured the path of the previously unknown planet—Pluto—on camera.

Doctors and surgeons realized the immense value of photographs in illustrating medical books and in documenting disease. Photographs were used to record varying degrees of burns, bone deformities, infections, and unusual skin and organ growths. A series of photographs might show the progession of a disease or different steps in a medical treatment. Even the X-ray process, which enables people to see through the body to bones and through other opaque objects, involves photographic film and developing techniques.

In 1931, Harold Edgerton, a graduate student at the Massachusetts Institute of Technology, was studying the behavior of electric motors under varying loads. But the motors spun too quickly for ordinary cameras to record their motion. So Edgerton developed an instrument called the electronic stroboscope (also called the strobe light or electronic flash). Affixed to a camera, the stroboscope enabled Edgerton to capture high-speed action. He produced "stop-action" photographs of hummingbirds in flight, bullets striking balloons, milk being spilled, and other fast-moving objects. Edgerton's work boosted knowledge in fields such as ballistics, the study of projectiles—such as bullets—in flight.

Other photographers concentrated on photography as an art form. One of the most famous photographers of the early 20th century was Ansel Adams, known for his photographs of the American West. Edward Weston produced dramatic portaits, landscapes, and pictures of the natural world. Both Adams and Weston promoted "straight photography," a style featuring sharp, detailed, and simple images.

Painters and other artists incorporated photographic images into their work. Some artists created photomontages (photographic collages). Others shot images after removing the camera's lens. Man Ray, an American artist living in Paris, created abstract works by directing beams of

Using an electronic stroboscope, Harold Edgerton was able to capture the motion of a tennis stroke.

Rayograph by Man Ray

light across photographic paper in the darkroom. The resulting images were dubbed "Rayographs."

DUST STORMS AND DEPRESSION

After a decade of prosperity following World War I, the stock market crashed on October 29, 1929. Millions of Americans lost their life savings, their homes, and their jobs. Economic depression blanketed the country. To make matters worse, a severe drought struck the Great Plains in the early 1930s. Dust storms swept across once thriving farmland. Hunger and despair gripped the nation.

To fight the Great Depression, the federal government, led by President Franklin D. Roosevelt, developed a massive recovery plan known as the New Deal. Under this program, the administration made loans to

farmers, built dams and highways, and started "back to work" programs—hiring citizens for government projects. To document the recovery effort, the government hired photographers.

University teacher Roy E. Stryker was chosen to head the government's photographic team. Working within an agency called the Farm Security Administration, Stryker picked highly qualified photographers for his staff. Walker Evans spent 18 months photographing poverty-stricken cities in the South. Russell Lee used flashlamps to capture images of despair and courage inside the homes of unemployed Americans.

When dust storms hit the plains, many farmers headed west. California was a golden land of opportunity, they thought, so families left their failed farms and set out to start a new life. The trip west, however, was

During the Great Depression, FSA photographers such as Arthur Rothstein took stark pictures of the drought-stricken West.

Dorothea Lange: *Migrant Mother,* **1936**

marked by despair. There was little work in California or elsewhere. Many families ended up in migrant labor camps, picking crops when work was available.

FSA photographer Dorothea Lange traveled the drought-ravaged West to record the plight of these Dust Bowl workers. Once, at a pea pickers' camp, she noticed a mother with small children. Fatigue and concern etched the woman's face as her children huddled around her. The pea crop had frozen, and the workers were practically without food. Meals consisted of frozen peas from the fields and birds the children had managed to kill. Even the tires from their car had been sold to buy extra food.

Lange's photos of the migrant family revealed the extreme poverty that was crippling the nation. When a San Francisco newspaper printed the pictures along with the family's story, concerned readers rushed relief supplies to the stranded migrants. "Ragged, ill, emaciated with hunger, 2,500 men, women and children are rescued after weeks of suffering by the chance visit of a Government photographer," read an editorial in the paper. Once again, the camera had moved a nation to action.

LIGHTS, CAMERA, ACTION

In this new publication, words and pictures should be partners.
—Publisher Henry Luce on the birth of *Life* magazine, 1936

Audiences in the darkened theater cheered. On the screen, doughboys charged out of trenches. Huge cannons belched fire, while flimsy airplanes twisted in dogfights with enemy fighters. Patriotic music, played by a live orchestra, muted the clattering sound of the film projector. Audiences sat tranfixed. The motion pictures on the screen, later called newsreels, were real images of war, shot in Europe by combat photographers. After the newsreel ended, audiences were treated to a more uplifting film, perhaps a slapstick comedy or a romance starring Gloria Swanson. The motion picture had arrived to stay.

For years, artists had made "moving pictures" by sketching a series of

small human or animal figures on pieces of paper. The sketches were practically identical, each picture showing only a slight change in the position of the figure. Stacked one on top of another and riffled by a thumb, the figures on the pages seemed to move.

Photographers copied this concept, using multiple cameras to photograph people and animals in motion. But no photographer could work the cameras quickly enough to capture a fluid series of movements. In 1878, Eadweard Muybridge, an English immigrant to the United States, hit upon a solution. He set up 12 cameras along a racetrack, each camera connected to a thread stretched across the track. As a horse galloped past, it broke the threads, releasing spring-loaded shutters on the cameras, which instantly took successive pictures of the horse's movements.

Muybridge used this process to photograph other animals and people in motion. Next, he invented a type of projector called a zoopraxiscope, meaning "animal motion machine." When run through the projector, Muybridge's photographs appeared to move, much like an artist's sketches on riffled paper. Images of horses running looked so real, noted one reporter, "that all that was missing was the sound of hooves."

By 1894, inventor Thomas Edison had perfected the hand-cranked kinetoscope, which projected a sequence of photographs to present a simple story. Since viewers had to squint into a box to see the pictures, Edison's films were known as "peep shows." They lasted about 30 seconds and cost a penny to view. Frenchman Louis Lumière's cinematograph projector, invented one year later, left audiences gasping as they viewed moving images of crowd scenes and a baby being fed breakfast. One early film that showed ocean waves breaking on shore made some viewers seasick!

A new term, movies, was added to the American vocabulary. Further refinements in both cameras and projectors made motion pictures a growing American industry. Early movies lasted only a few minutes and were generally shown in stage theaters and dance halls. Stores, too, were converted into movie houses. Charging five cents for admission, these theaters were called nickelodeons.

"Some of these places are perfectly filthy, with an air so foul and thick that you can almost cut it with a knife," reported *Moving Picture World* in 1911. "The floor is generally covered with peanut shells, and as there is no stove to spit [tobacco] on everybody spits on the floor." As movies became more elaborate, however, theaters got fancier too, with thick carpets and glittering chandeliers. Attendance skyrocketed from 40 million viewers in 1922 to more than 65 million in 1928.

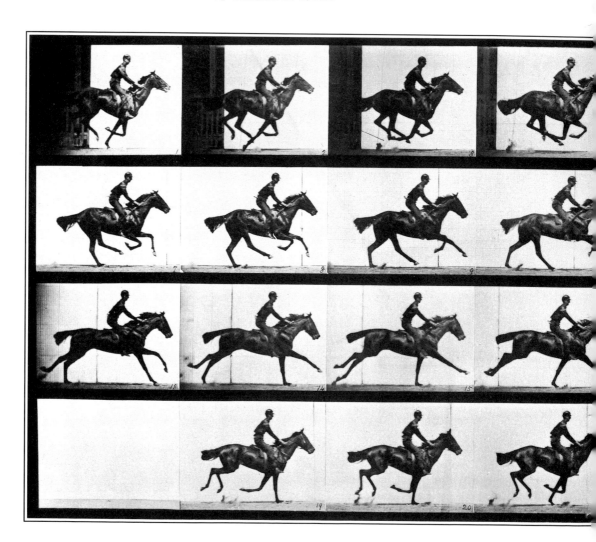

Surprisingly, movies of the early 20th century did not give credit to their stars. Producers were afraid that well-known players might demand high salaries. Audiences, however, soon developed favorites and demanded to know where and when the stars were born and whether or not they were married. Many early film stars worked hard to gather a loyal following. "As soon as my pictures arrive from the photographers," Mary Pickford wrote to a fan, "I will gladly forward you one."

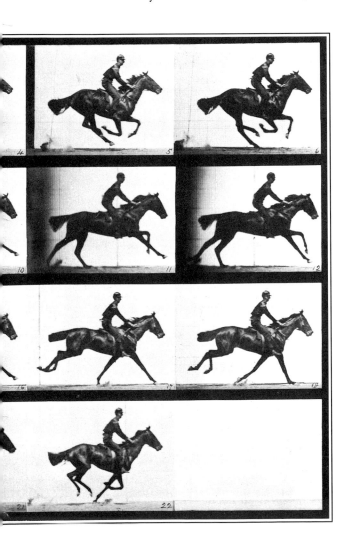

When run through a projector, these photographs by Eadweard Muybridge seemed to move.

Silent movie set, 1920s

Fan magazines such as *Photoplay* and *Motion Picture Story* began to print pictures of the stars. Millions of women wanted to wear long, blonde curls like Mary Pickford's. Men adopted the slicked-back hairdo of Rudolph Valentino. In the 1930s, when clothing makers sent out publicity photos of Marlene Dietrich and Katharine Hepburn wearing slacks, the fashion spread from southern California across the country. British and German clothing makers complained that American movies were ruining their business—suddenly, audiences wanted to wear only American styles.

Manufacturers realized the value of photography in marketing their products. Photographs were printed on packaging, in magazine spreads,

and on roadside billboards. Magazines like *Vogue* and *Vanity Fair* printed fashion photographs using professional models. "A good model will earn $40 to $60 a week, plus expenses," reported *Popular Photography* magazine in 1937. "The minimum rate is $5 for the first two hours, $2.50 for each additional hour, or $15 a day."

Celebrity was not limited to film and fashion. Daily newspapers featured photographs of football sensation Red Grange and other athletes. Action pictures of boxer Jack Dempsey helped attract thousands to prize fights. Cameras not only relayed the drama to readers at home, they were also part of the competition. Photographs were used to determine winners of close finishes in horse races—much the same way instant replay would be used to rule on close calls in football years later.

As spectators flocked to stadiums to watch baseball stars like Ty Cobb and Babe Ruth, news photographers rushed in too. At first, photographers actually came on the field to take pictures, but they often collided with players trying to catch foul balls—even running the base paths. In 1911, cameramen were banned from the field of play.

Before and after games, photographers like Carl J. Horner took pictures of sluggers and pitchers. These photos were printed on small cards—baseball cards—included in packs of cigarettes and, later, bubble gum. The trend began in the 1890s, when tobacco companies and cocoa manufacturers included tiny portraits of stage stars as gifts inside their packages. Like carte de visites of the 1860s, baseball cards were collected and traded.

LIVING COLOR

In 1920, after years of hard campaigning, women finally received suffrage—the right to vote. Cameras captured the spirit and power of the suffrage movement but were unable to capture its color. Yellow, the official color of the suffragettes, was displayed in thousands of buttercups, daisies, and dyed plumes worn by marchers nationwide. Unfortunately, cameras only recorded these items in shades of gray.

Early daguerreotypists had tried to capture colors on metal plates, but

Manufacturers used photographs to advertise everything from cigars to new cars.

had had little success. In 1907, photographers were able to produce color images using a process known as autochrome. The process produced beautiful images, but the colors, preserved between two thin plates of glass, faded easily.

By the early 20th century, the Eastman Kodak Company had grown into a huge firm by buying out its rivals, making agreements that stores would sell only Kodak products, and developing new types of cameras and film. In 1939, the company introduced Kodachrome film, capable of taking color photographs.

Color photography is based on the concept that red, blue, and green light can be mixed to create any color of the rainbow. Kodachrome film was simple to produce, easy to work with, and affordable. Color photography—used mainly by professionals at first—helped usher in the era of photo newsmagazines such as *Life* and *Look*. Americans had come

Press photographers, 1936

to expect pictures with the news—now the news was in color. *Life,* in particular, employed gifted photographers—Margaret Bourke-White, David Duncan, Eugene Smith, and many others—to bring images to its readers. During World War II (1939–1945), *Life* employed 21 full-time photographers.

The year 1939 marked 100 years of photography. By then, millions of Americans owned cameras, using them to capture images of vacations, celebrations, and other special events. In the years following, cameras and photographs became even more widespread. Students lined up for yearly school photographs. Photos appeared on passports, driver's licenses, and family Christmas cards. Kids posed for goofy pictures in bus stations and drugstores, where do-it-yourself photo booths offered four prints for a quarter.

Cameras improved, attracting amateur photographers with features like adjustable focus and interchangeable lenses. But most Americans just liked to take snapshots. In 1963, Edwin Land introduced his Polaroid Land Camera. Using special film and self-developing chemicals, the camera produced a color print in less than six seconds. Meanwhile, television and videocassette recorders brought moving pictures from the big screen to the average American living room. Of all the improvements in the field of photography in recent years, perhaps one of the more dramatic is ability of computers to colorize, enhance, even change the content of photographs.

The camera has witnessed wars, social change, and fortunes won and lost. Families have recorded their history with the camera, and the camera has recorded the history of the United States. As *Life* publisher Henry Luce noted in 1936, photographs allowed people

> To see life—to see the world, to eyewitness great events; to watch the faces of the poor and the gestures of the proud . . . to see strange things . . . to see man's work . . . to see and be amazed; to see and be instructed.

Most of all, photographs allowed Americans to see themselves.

SELECTED BIBLIOGRAPHY

Andrews, Ralph W. *Picture Gallery Pioneers, 1850–1875.* Seattle: Superior, 1964.

Current, Karen. *Photography and the Old West.* New York: Harry N. Abrams, Inc. 1978.

Goldberg, Vicki. *The Power of Photography.* New York: Abbeville Press, 1991.

Henisch, Heinz, and Bridget Henisch. *The Photographic Experience, 1839–1914.* University Park: Pennsylvania State University Press, 1994.

Katz, D. Mark. *Witness to an Era: The Life and Photographs of Alexander Gardner.* New York: Viking Studio, 1991.

Meredith, Roy. *Mr. Lincoln's Camera Man, Mathew B. Brady.* New York: Dover Publications, 1974.

Moeller, Susan. *Shooting War.* New York: Basic Books, 1989.

Newhall, Beaumont. *The Daguerreotype in America.* New York: Dover Publications, 1976.

Pollack, Peter. *The Picture History of Photography.* New York: Harry N. Abrams, Inc., 1969.

Rinhart, Floyd, and Marion Rinhart. *The American Daguerreotype.* Athens: University of Georgia Press, 1981.

Rosenblum, Naomi. *A History of Women Photographers.* New York: Abbeville Press, 1994.

Sante, Luc. *Evidence.* New York: Farrar, Straus & Giroux, Inc., 1992.

Taft, Robert. *Photography and the American Scene, A Social History, 1839–1889.* New York: Dover Publications, 1938.

Tilden, Freeman. *Following the Frontier with F. J. Haynes.* New York: Alfred A. Knopf, Inc., 1964.

Tractenberg, Alan. *America and Lewis Hine.* New York: Aperture Foundation, Inc., 1977.

Welling, William. *Photography in America: The Formative Years, 1839–1900.* New York: Thomas Crowell, 1978.

Willis-Thomas, Deborah. *Black Photographers, 1840–1940.* New York: Garland Publishing, Inc., 1985.

INDEX

ACKNOWLEDGMENTS

Photographs and illustrations reproduced with permission of The Bettmann Archive: pp. 2, 12, 18, 22, 46, 48 (bottom), 52, 55, 74, 80; Library of Congress: pp. 6 (10623), 7 (19393), 58 (53123), 71 (4376); Archive Photos: pp. 8, 42; Gernsheim Collection, Harry Ransom Humanities Research Center, The University of Texas at Austin: pp. 9, 56; Cambridge University Library: p. 14; George Eastman House: pp. 20, 51, 76-77, 83, 88; National Archives: pp. 23 (111-B-5454), 24 (111-B-322), 27 (111-B-65), 28 (165-C-777), 30 (57-HS-78), 32 (77-WA-11), 37 (79-BC-166), 62 (102-LH-1941), 66 (111-SC-2913); Pasadena Public Library, A. C. Vroman Collection: p. 31; Denver Public Library, Western History Department: p. 35; Solomon D. Butcher Collection, Nebraska State Historical Society: p. 39; Philadelphia Museum of Art, purchased with funds from the American Museum of Photography: p. 40; Museum of Art, RISD: p. 43; Special Collections, University of Vermont Library: p. 45; The Art Institute of Chicago, Gift of Harold Allen, 1976.1005: p. 48 (top); Oakland Public Library: p. 57; The Jacob A. Riis Collection, #101, Museum of the City of New York: p. 60; Captain A. W. Stevens, © 1936, National Geographic Society: p. 67; The Harold E. Edgerton 1992 Trust, Palm Press Inc.: p. 69; The Museum of Modern Art, New York. Gift of James Thrall Soby. Reprinted with permission from the Man Ray Trust: p. 70; The Dorothea Lange Collection, The Oakland Museum of California, The City of Oakland. Gift of Paul S. Taylor: p. 72; Springer, Bettmann Film Archive: p. 78; UPI/Bettmann: 81.

Front cover: Collection of the Oakland Museum of California, Burden Photography Fund
Back cover: Library of Congress (26579)

1915. "Now Look Pleasant, Please."
Copyright, 1897, by Littleton View Co.